Killing Poetry

Killing Poetry

~

Blackness and the Making of Slam and Spoken Word Communities

JAVON JOHNSON

Rutgers University Press

New Brunswick, Camden, and Newark, New Jersey, and London

978–0–8135–8001–2
978–0–8135–8002–9
978–0–8135–8003–6
978–0–8135–8004–3

Cataloging-in-Publication data is available from the Library of Congress.

A British Cataloging-in-Publication record for this book is available
from the British Library.

∞ The paper used in this publication meets the requirements of the American
National Standard for Information Sciences—Permanence of Paper for Printed
Library Materials, ANSI Z39.48–1992.

www.rutgersuniversitypress.org

Manufactured in the United States of America

For my mother, Valerie Cannon-Mijares. I am because you are.

Contents

Preface

I was putting the finishing touches on *Killing Poetry* as I learned of my stepfather's imminent passing. Pastor Foster T. Mijares III will not be around in the physical form to witness his stepson publish a book. On some level, I feel like a bit of a failure for not having completed the manuscript in time for him to hold and read it. In my family, he was the one who asked most often about my work. "Hey, J," he'd say. "How's teaching? How's the book coming along?" From there, we would talk church, family, politics, and sports, usually in that order. He would always end our conversations by saying, "I know you're busy, and I didn't want to keep you long. I just wanted to check in on you to let you know I'm thinking about you." I always tried to assure him that, although I am busy, I always welcomed and needed our conversations.

I spent half a year working on what should have taken me less than a month because every period was a painful reminder that my stepfather would not be able to read this book in its final form. That knowledge is incredibly difficult for me because I had made a political commitment to write in ways that would allow my parents, who never went to college, to engage with my work. When I told him of this, he said, "It's all right. God got me. I want you to keep doing what you do. You ain't got to apologize to me. I'm proud of you no matter what." My stepfather was a patient man. At various points in his life, he was a pastor, a volunteer youth football coach, and a truck driver. He was a man strong enough to take care of those who were not his own. I often joked with him about his restraint in dealing with teenage me. When he and my mother

married, I was a fourteen-year-old angry black boy who thought he knew everything, and it was my stepfather's love, patience, and guidance that helped me to search for and understand healthier black masculine possibilities.

When my mother called me to tell me of my stepfather's lymphoma, I was sitting in my apartment in gentrified Oakland, California. The Oakland that MC Hammer had once quipped was "too legit to quit" was now no longer a bastion of blackness, no longer the Black Panther Party for Self-Defense Oakland, but a white hipsters' playground with fancy wineries and obscure boutiques. At the same time, I was reading about how the state had murdered yet another black person. The looming death of my stepfather, the death of a black city, and the state-sanctioned death of black bodies all over the nation left me quite preoccupied with, well, death. In my stepfather's case, death took its time to claim what it was coming for. It was tough to see him grow frail and unable. Yet, in the end, while it was incredibly painful to watch a man who had once been strong enough to move trucks, football teams, and congregations become too weak to get out of bed, it was beautiful to witness how sweet and kind he had become. He frequently called or texted me just to say "I love you." And this is how I began to think about death as less like an ending and more like the possibility of something else, of something more.

In its simplest terms, *Killing Poetry* is a search for something else and something beyond. It is a search for a more livable world in which black folks, in all of our complex contradictions and beautiful brilliances, can just be. This concept is not new in any way. I am not the first person to embark on this black voyage, nor will I be the last, but the quest is the only prayer my heart knows at this moment. And as an artist, an activist, and an academic, to borrow from Dwight Conquergood's (1985, 41), "three *a*'s of performance studies," I've found that it is the only thing I am able to write about. "Like poetry, anthropology is a quest for education in the original sense of the term," writes the anthropologist Tim Ingold (2014, 388); they are both a "practice of *exposure*." From black poets such as Danez Smith (2014), who "left earth in search

of darker planets" in his "Dear White America," to queer, women, and trans poets who are also in search of other (Other?) planets, the slam and spoken word artists I studied—and studied with—consistently focus on humanness and culture in an attempt to create and find a better, more loving, and more livable world.

When I was a college freshman, I would not have been successful in most creative writing programs. But Da Poetry Lounge in Hollywood, California, took me in and trained me, and now I am a well-recognized contemporary spoken word poet who has taught classes and workshops in creative writing programs all over the world. At the very least, the slam and spoken word poetry communities I write about in *Killing Poetry* have created more open and accepting creative writing spaces and programs. They have fostered environments in which participants search for something beyond. Like many of the poets I interviewed for this book, these communities, though sometimes problematic, saved my life. In exploring this tension between the problematic and the possible, I hope to add to a conversation that will help such communities become more dynamic, more radical, and more beyond.

My creative writing style follows the performance studies tradition and is grounded in political and ethical commitments to produce work for and with the communities I study and study with. But, honestly, I've never wanted to be an academic writer. I want to be a creative, generous, and caring writer who tells stories about love. So, above all, *Killing Poetry* is a product of and about love. I sincerely hope that the love I have for poets and our communities shines through and beyond these pages. Given that I refuse to believe in the finality of death, I am also hoping that maybe my stepfather, somewhere in the great beyond, will read this book and say, as he used to say so often from the pulpit, "Lawd, have mercy. That's good."

Killing Poetry

1

Let the Slam Begin

History, Method, and Beyond

Cemeteries are just the Earth's way of not letting go. Let go.
—Buddy Wakefield, "We Were Emergencies"

In the spring of 2000, the *Paris Review* published its sixth edition of "The Man in the Back Row Has a Question" in which noted literary figures discussed poetry's past, present, and future. Answering a question about the hallmarks of a good poem, the literary critic and humanities professor Harold Bloom anxiously called poetry slams "the death of art." As the lone figure to mention them in an interview that had nothing to do with the increasingly popular phenomenon, he seemed to have been waiting for any opportunity to unload his frustrations. After pining over the works of Milton, Blake, Shakespeare, Crane, Yeats, Stevens, and Whitman, he suddenly veered off-topic: "And, of course, now it's all gone to hell. I can't bear these accounts I read in the *Times* and elsewhere of these poetry slams, in which various young men and women in various late-spots are declaiming rant and nonsense at each other. The whole thing is judged by an applause meter, which is actually not there, but might as well be" (Barber et al. 2000, 379).

Bloom's claims about slam and his list of poets who know how to use "exactly the right word in exactly the right context" read

like white male angst (Barber et al. 2000, 379). Because poetry slams represent a forced diversity in terms of bodies, content, and structure, his dismissal is a trite and terrible attempt to save white male normativity, white structures, and the supposed sanctity of the white literary world. Even the mention of an applause meter points to the assumption that only the great literary critics, who are far too often white and male, possess the ability to adequately assess good literature. His comment made many the poets who slam feel as if all of academia were against our work and us. While some creative writing programs and English departments do not recognize the literary merits of slam, many do; and numerous campus program boards and departments are excited to bring slam and spoken word poets to their campuses to perform, lecture, and conduct workshops.

Bloom's generalized dismissal, which is well known in slam and spoken word poetry communities for having reduced slammers to non(sense) poets, failed to account for the many slam participants who have earned degrees in creative writing from respected programs, published in reputable journals, and won highly coveted writing awards. Plenty of us have tried in earnest to prove we are not the death of art by emulating and participating in the very structures that Bloom accepts as legitimate. I appreciate these efforts, but I am also incredibly interested in slam and spoken word poets who imagine and build institutions and coalitions beyond and outside of the academy. My hope is that, rather than trying to prove our merit and usefulness to the literary world, we can consider the possibility that the death of art—at least in the ways in which Bloom imagines art—can be generative.

The Poetry Slam or Slam Poetry

The poetry slam is the competitive art of performance poetry. It puts a dual emphasis on writing and performance, encouraging poets to focus on what they are saying and how they are saying it. In contrast, spoken word can happen in an open mic format without structured competition or scoring. Traditionally, poetry slams

consist of multiple poets who are judged by five randomly selected audience members. Immediately following each performance, the judges rate the competitor, using a rubric with a low of 0 and a high of 10, encouraging decimal points in order to decrease the chance of ties. The bout manager drops the highest and lowest scores and averages the middle three scores, and the total may range from 0 to a perfect 30. The rules of individual venues vary—for instance, in the number of rounds required in a bout—but the energy and spirit of the slam remain consistent.

Spoken word poetry existed long before the poetry slam; the competition element was a trick or a tool to draw people back into poetry. These poets belong to the lineage of radical theater, which refuses the confines of the traditional stage. They create poetic spaces everywhere: coffee shops, record stores, theaters, bars, bookstores, restaurants, homes, and community centers. Yet despite their association with radical politics, they are open to a wide range of styles and topics. In a way, there is no genre called slam poetry: "the key to understanding [it] . . . as a body of work has little to do with form or style . . . because a range of forms, tones, and modes of address exist in slam practice" (Somers-Willett 2009, 9). Yet I like to think of the poetry slam as a range of aesthetic possibilities beyond present standards and forms. While a number of popular modes and styles have come to symbolize poetry slams—so much so that the collective imaginary may assume that the poetry slam is a new genre called slam poetry—I believe that slams and the spoken word communities that often center around them are about ever-emerging possibilities.

A Slamming History

I am sitting in Chicago's Green Mill Cocktail Lounge. Smoke fills the air, wrapping itself around my neck like a warm scarf on a winter morning, and I choke and cough. I am very uncomfortable, but I figure this is what all ethnographers must go through. The lounge, with its poor lighting and congested seating, is built for jazz. Faux wood paneling lines the walls, and hanging just

behind the stage is a gauche stylized neon tube light that spells out "Green Mill." A piano sits stage-left. I immediately imagine a cheesy lounge singer lying on top of it, singing a tune no one wants to hear. A microphone stands at center stage, and an older white man named Marc Smith grabs it and enthusiastically announces:

> The poetry slam is a competition invented in the 1980s by a Chicago construction worker named Marc Smith. ["So what?" the audience screams in response.] This is the slam, everybody. There are slams all over the world, but this is the original slam. I started it all. What makes a slam different than your ordinary poetry reading is that you, the audience, is in control. If you don't happen to like something, you do this [snaps fingers]. This don't mean dig me daddy-o, those guys are dead. If you really don't like it, you do this [stomps foot]. Years ago we created the feminist hiss [women in the audience hiss]. It used to be for when a man did something to offend women, but now it's virtually for any man for simply stepping on the stage. ["And that's the way it should be!" women yell.] Oh, I have something in my eye, honey [uses his middle finger to dig at the corner of his eye]. ["Here, let me help you dig it out!" women yell and stick up their middle fingers.] In response, we men have created the masculine grunt [men in the audience grunt weakly]. (Poetry Slam Inc. n.d.)

Marc and the audience perform this pre-slam mantra weekly. Likewise, in every national and regional bout, and even at some local bouts, a bout manager enacts a version of this ritual before the competition. It is performed in every major documentary about slam and appears in most books that deal with the phenomenon. The audience's energetic "So what?" response to Marc's role as the slam papi isn't meant to disavow his importance.[1] Rather, the ritual reestablishes "certain customary norms and ethical standards" in which the slam papi assumes his place as the unquestioned patriarch, the father who created the slam and deserves recognition for doing so (Turner 1982, 95).[2]

Though the history of the poetry slam is brief, it is also vexed. Some cultural insiders and outsiders contest the well-known narrative, but most would agree that the slam began "in 1984, [when] construction worker and poet Marc Smith started a poetry reading at a Chicago jazz club, the Get Me High Lounge, looking for a way to breathe life into the open mike format" (Poetry Slam Inc. n.d.). He sought to give audiences a way to voice their responses to what he suggested were pretentious, monologic, and monolithic poetry readings. When I interviewed him in April 2007, he argued that "traditional poetry readings were boring and self-serving because they had poets reading to only hear themselves, and I wanted to change that." He continued, "I wanted to merge performance and poetry. You young poets don't know how hard it was to do that. Many poets thought I was crazy because they thought that performance would sully the poetry, but I didn't care."

Eventually, he needed more space, and "in 1986, Smith approached Dave Jemilo, the owner of the Green Mill (a Chicago jazz club and former haunt for Al Capone), with a plan to host a weekly poetry [show on Sunday nights]" (Poetry Slam Inc. n.d.). Jemilo welcomed him, and the poetry slam began to grow into the event that would later sweep the nation. Yet it was not originally about competition but a cabaret-influenced performance poetry reading, complete with costumes, wild acts, and—perhaps most importantly—the involvement of raucous audiences. Marc told me, "Originally, we didn't know what we were doing. We just knew we had to do something, and that didn't always involve competition. . . . That came one day when the show was running a bit early, and I kept the competition in my back pocket just in case I needed it." After "it took off . . . and Al McDougal became the first slam champion," the term *slam* became synonymous with competition, he told me, because it was easier, and perhaps more enticing, for the media to write about a competition than about an entire show, which could be "too complex" and required "time or space."

In July 1986, Marc coined the term *poetry slam*. It appeared in print later that month in "Poetry Boosters Slam Snob Image," Lynn Voedisch's *Chicago Sun Times* article on his weekly event.

"Who can argue?" she writes. "Poetry readings have always smacked of snobbery. Too often, intellectual poseurs sniff through readings of obscure scribblings, while jaded members of the sparse audience nod their heads in subdued agreement. It's not exactly a happening scene." Labeling Marc and his colleagues Ron Gillette and Jean Howard "poetic thespians," she asks, "But then there's the question of that name. Just why is this event labeled a 'slam?'" The answer Marc gave her was nearly identical to the one he gave me twenty-one years later: "'Well, I thought, everybody would think a slam, to hell with poetry, but then I started thinking about a grand slam in baseball and even in bridge. And, well, I had to get the flier out . . . , so that's the name I went with'" (3).

Voedisch's seminal article brought the term into public discourse, first in Chicago and soon throughout the nation. A week after it appeared, the *Chicago Tribune* ran the first advertisement for the "Uptown Poetry Slam" held at the Green Mill. By November 25, the term had made its way into the *Los Angeles Times* (in Larry Green's "It Could Be Verse: Performance Poets Liven an Old Art"). On August 24, 1987, it appeared in the *Wall Street Journal* (in Alex Kotlowitz's "The Boozer As Critic: Poetry Is Brutal Sport in a Chicago Barroom"). Yet even though a few local poetry readings across the country began experimenting with the poetry slam, the notion did not take off in most cities until after 1990, when "the first National Poetry Slam (NPS) competition was held in San Francisco as part of the third Annual National Poetry Week Festival." After that, slams began cropping up in Midwest cities beyond Chicago, then in Boston, New York, and San Francisco, and finally everywhere. "The movement had gone national" (Smith and Kraynak 2004, 14–15).

With the help of Paul Devlin's documentary *Slam Nation* and the film *Slam* (both released in 1998), the national competition grew quickly. That growth was amplified when *Russell Simmons Presents Def Poetry Jam* debuted in 2002 as both a Broadway show and an HBO series. Writing in the *New York Times*, Stephen Holden (1998) captured the impact of these films and performances: "They have helped make poetry sexy again in a way it

hasn't been since the heyday of the Beats" (B12). The 2003 national competition boasted record-breaking numbers of both competitors and audience members, yet both records were shattered in the years following. In addition to PSi's national competition, other major events include Youth Speaks' Brave New Voices National Poetry Festival, PSi's Women of the World Slam, and the annual College Union Poetry Slam Inc. (Poetry Slam Inc. 2016).

The advent of poetry slams in the 1980s marked an important moment in the revival of spoken word poetry. Although Marc Smith himself documents a history of performance poetry that predates his slam, his "poetry with a theatrical flourish" deserves critical attention because it "liven[ed] an old art" (Green 1986, A1). Performance scholar Jill Dolan (2005) has called slams' concentrated intensity a "utopian performative": one of those "small but profound moments in which performance calls the attention of the audience in a way that lifts everyone slightly above the present, into a hopeful feeling of what the world might be like if every moment of our lives were as emotionally voluminous, generous, aesthetically striking, and intersubjectively intense" (5). In the truest sense of the performative, slam and spoken poets are doing material things with words. Dolan and many others (for instance, Fisher 2005, Parmar and Bain 2007, and Woods 2008) remark on the utopic, alchemic, and democratic possibilities in slam and spoken word poetry, whether in bringing a younger and more colorful audience to Broadway, performatively practicing democracy, or empowering our youth. Not only has this repopularized phenomenon attracted the hearts, ears, and attention of millions within the past couple of decades, but it has also created an amazing network of young poets and loving relationships. For some, such as Darnell "Poetic" Davenport of Los Angeles, it saves lives. Devin "Poetri" Smith, also of Los Angeles, told me, "It's my prayer." Aja Monet of New York said, "I do this for my life. It is in creativity that we see the God in ourselves." I lost count of the number of poets who explained to me, "This is how I breathe." All of them are a testament to the power of poetry and performance.

While these narratives need to be told and retold, the discussions of slam and spoken word poetry in popular media and academic circles have glossed over some crucial details. Although poetry slams have contributed to a resurgent interest in performance poetry, there has been little critical dialogue that fully engages with the complexities of performance poetry communities. Even Marc Smith and Joe Kraynak (2004) and Felice Belle (2003), all of whom are deeply invested in performance poetry and write about slam and spoken word poetry communities, ultimately fail to account for the problematic ways in which these communities are produced. In other words, while the writers are important members of the communities, their work is not backed by ethnographic research. They largely focus on discussing poetry slams but not the communities that are so vital to understanding them. Recent academic and popular writings on performance poetry are mostly concerned with its presentational style (Dillard 2002; Martin 2002; Ellis, Gere, and Lamberton 2003), or they romanticize the remarkable diversity of performance communities while failing to account for the performers' underlying racial, gender, class, and sexual dynamics, through which the notion of community becomes contested rather than utopian (see Echlin 2003). In some instances, the literature suggests that performance poetry may be used as a strategy to invite students into other (often read as canonical) styles of poetry (Ellis et al. 2003). Yet there is little dialogue that critically questions the ways in which these highly politicized performance communities are produced and reproduced, maintained and negotiated, or empowered and subverted. By examining the performances of race, gender, sexuality, and class in the making of slam and spoken word poetry communities, I hope to address this absence.

Getting to Slam

I attended my first poetry slam in Los Angeles in the summer 2001. Earlier that year, during the spring, a college buddy, Armando Roman, who knew I wrote poetry, asked if I wanted to go with him

to "see some slam poetry." I happily said yes, but our first attempt ended in an auto accident in which his beloved, hard-earned car was completely totaled. Luckily, everyone walked away without serious injury, and a few months and one car later, we went out to see the slam teams from Hollywood, Los Angeles, and Orange County perform before heading off to the national competition. The event was held in the now-defunct Atlas Café; and while I cannot remember much about the space, I do remember seeing amazing poets such as Shihan Van Clief, Devin "Poetri" Smith, Sekou "Tha Misfit" Andrews, Rachel McKibbens, Buddy Wakefield, Omari Hardwick, Gina Loring, and so many others.

To riff on one of Shihan's well-known poems, the room was filled with "flashy words." The excitement was palpable and was compounded by the throbbing hip-hop bass lines interspersed throughout the show, courtesy of Da Poetry Lounge's resident DJ, Brutha Gimel. Born and raised in the Acres Homes section of Houston, Gimel Hooper had made his way to Los Angeles in 1992 to try his hand in the entertainment industry. He is a thin, dark-skinned brother who stands about five feet, seven inches tall and is unapologetically hip-hop and Afrocentric. On the night I met him he was wearing a dashiki, a pair of shell-toe Adidas sneakers, and a natural haircut. At the time I did not understand that his appearance was a near-perfect symbolic representation of who he is: Gimel, who once told me he "should have been born in the sixties," is one of the most generous and genuine men I have ever met.

At the end of that night's show, I walked up to Gimel and said, "Yo, man, this is incredible. Where else do you all do this?" He handed me a few fliers and gave me a quick rundown of the slam scene. He mentioned that Da Poetry Lounge in Hollywood was "a big stage" and suggested that I might want to sharpen my skills at a smaller venue first. Omari Hardwick (now of Starz's *Power* fame) then joined our conversation, and both he and Gimel insisted that I should come back. I left the venue buzzing with excitement. I remember feeling as if I had found a community of people to whom I did not have to explain and justify my complexities. I had grown up on a diet of football, gangster rap, and fistfights, so it was

not always easy to explain my love for theater, choir, speech and debate, drawing, and poetry. I am not saying that others derided my affinities. Rather, I myself could not understand the seeming contradictions in art and manhood. As a straight cis-gendered black boy raised in 1980s South Central, Los Angeles, I had always thought the arts were spaces for the gay boys, yet there I was, singing in the choir, performing in our school's theater productions, and writing poems, just trying to make sense of the "fuzzy edges" of my masculinity, to invoke Mark Anthony Neal (2005, 9).

As soon as we got back into the car, Armando and I began frantically recapping the night. We laughed, shouted, and recited lines that had taken our breath away and, more importantly, those that had given us new breath. As he dropped me off, Armando turned to me and said, "Hey, man, we gotta go back. I can't wait till you get to read." I smiled: "Any time, brother. Let me know when you can make it back out."

For the next few weeks, Armando and I religiously attended Jerry Quickly's "Thirty-Three and a Third," a small open mic held in a Silverlake record store, whose walls were lined with nearly every important album cover I knew. Now gentrified, Silverlake was once an ethnically diverse neighborhood, and Quickly's open mic—featuring, among others, an Asian rap group, a seemingly homeless Latino man whose poems were all about the neighborhood's changing demographics, and hipsters—reflected as much. After performing for three consecutive weeks in the store, Quickly, along with Sekou Andrews and Corey "Besskepp" Cofer (who had founded and was still running A Mic and Dim Lights, an open mic in Pomona), told me to head to Da Poetry Lounge. I distinctly remember Sekou and Besskepp saying, "You're ready."

I arrived at Da Poetry Lounge, known as DPL, on a Tuesday night at the end of August. Located on Fairfax Avenue, just a block south of Melrose Avenue, the venue is nestled on the borders of Los Angeles and West Hollywood. Founded by Shihan, Poetri, and Gimel as well as Dante Basco (who famously played the rebellious Rufio in Disney's *Hook*), DPL takes place in Greenway Court Theatre, a ninety-nine-seat black box in which Al Pacino, Jason

Alexander, and many others have performed. The theater is part of the Greenway Arts Alliance, "a community-based partnership" co-founded by Whitney Weston and Pierson Blaetz that "unites communities through art, education, and social enterprise" via its Institute for the Arts, the Melrose Trading Post, and the offerings in the theater itself (Greenway Arts Alliance n.d.).

DPL is held every Tuesday night at 9 p.m., except for holidays, and each week it attracts between two hundred and three hundred people to hear, see, feel, and experience poetry as an embodied engagement. On the night I first arrived, the line was stretched down the street. I made my way up a short flight of stairs and past a gate to the entrance, where Shihan greeted me and all of the other audience members. The energy was electric, as hard hitting as the music that was forcing its way outside to meet us long before we were able to walk in. The people in line were talking about this "amazing place," as one young woman put it, and it did not disappoint. After making my way through the small lobby, I found myself inside a theater packed with artists, couples on dates, groups of friends, working professionals, students, and everyone else you can imagine, all of them anxiously waiting for the night to begin. I now know that this atmosphere is typical of DPL: we have to regularly turn people away in order to comply with fire codes.

Greenway is a small theater, but its forty-foot-high ceiling and forty-by-sixty-foot performance space allows it to feel both roomy and intimate.[3] Its walls are painted green as an homage to its name, while the rest of the space is black, "well, because it's a theater," as the producing director/managing producer Ty Donaldson told me in June 2015. Like most theaters, part of what makes Greenway magical is its malleability, and the space is frequently reconfigured for various productions. On the night of my first visit, however, the stage was undecorated, filled only with a circle of people arranged around a single microphone at center stage. Gimel, whose DJ booth was set up in the back of the stage, was still spinning vinyl through Greenway's basic eight-channel Mackie sound system. I made my way up to the stage to speak to Poetri, who was the host: "Hey. I'm Javon. Sekou told me to come talk to you about performing

tonight." He responded, "OK. Cool. I got you, big dog." I have come to learn that the nights resemble the particular hosts. Poetri is playful, and his nights often feature games such as Slide or silly trivia, whereas Shihan's are usually filled with jokes about random observations and his family.

On my first night at DPL, I heard incredible poems, freestyle rap verses, a comedian, and a singer, while Gimel provided music between performances to keep the energy lively. Near the end of the night, Poetri grabbed the mic and half-jokingly said, "The next guy I'm calling up is going to close, . . . so he better be good. A few people told me about this young brother, so I don't know. But put your hands together for Javon Johnson." I stood up at the mic and performed a piece about racism and poverty. When I was done, Poetri came back on stage and yelled, "Yeaaaaahhh, boy. That's what I'm talking about. You got to come back, big dog." And I did, nearly every week for the next fifteen years.

I use words such as *we* and *us* when referring to poetry slams, spoken word poets, and their communities because I have been part of these communities since 2001. I am a two-time National Poetry Slam champion. I made it to Poetry Slam Inc.'s final stage seven times in my eleven years of competition, coached teams to finals and semifinals in national competitions, appeared on HBO's *Def Poetry Jam*, BET's *Lyric Café*, TVOne's *Verses & Flow*, CBS's *The Arsenio Hall Show*, and NBC Universal's *The Steve Harvey Show*. I toured with Jill Scott; wrote for Nike, Showtime, and the National Basketball Association; created and co-hosted an open mic in Oakland called Amp; and mentored youth poets. I co-produce Button Poetry Live in Minneapolis and am regularly invited to perform at colleges and universities as well as major national and international stages such as Radio City Music Hall and Wole Soyinka's eightieth birthday celebration in Abeokuta, Nigeria. I was involved in slam and spoken word long before I decided to become an academic. In short, I am not a researcher who does art but an artist who has decided to research these critically creative communities.

In Search of the Beyond

At the beginning of most poetry slams, the bout's host calls up a sacrificial poet, usually saying, "Before we can start, there must be blood spilled on this stage." The audience typically responds with "Baaaaaaaa," until the performer begins. Also known as a calibration poet, this sacrificial lamb performs only once, forgoing his or her chance to advance in or win the slam. The poet's sole job is to set the standard for the night, to give the judges a test run at scoring before the actual competition begins, and—in true Abrahamic fashion—to die for the greater good.

Beyond the ritualism of this particular process, it is useful to point out precisely how killing and death is a large part of the general slam culture. For instance, when a poet brilliantly performs a well-written piece, he or she has *killed it*. Then there is the *suicide slot*, the first performance position after the sacrifice. Because of score creep (that is, the tendency of judges to score poems higher at the end of the bout than they do at the beginning), those who manage to win from the suicide slot—that is, come back from the dead—are revered. When a poet or a team are so far behind in competition that it would be mathematically impossible for them to win, they are sometimes referred to as dead. Yet rather than thinking about these moments of death as the end, slam and spoken word illustrate how they are moments rife with generative possibilities. To sacrifice one poet is to bring forth an entire poetry slam, filled with multiple bodies and competing voices. A poet who wins a bout from the suicide slot is the closest thing we have to a miracle in poetry slam competitions. Jill Dolan (2005) no doubt witnessed poets killing poems on stage during those moments of utopia she experienced while watching *Def Poetry Jam* on Broadway. Even mathematically dead teams talk about their inability to win as the birth of a new possibility, for they are now able to read a wider range of poems that may not score well but could spark meaningful dialogue.

It is this mode of thinking—in which death is the beginning of another possibility, something beyond rather than an end—that

compels me to read Bloom's "death of art" comment as an indictment not of poetry slams but of the failures and inadequacies of white male–centered art cultures. By *something beyond*, I mean spaces, moments, and possibilities defined in radical difference from the here and now. Grounded in Edward Soja's (1996) discussion of Henri Lefebvre's stubborn insistence that "there is always an-Other" possibility, slam and spoken word communities' search for something beyond does more than renegotiate and contest boundaries or challenge "the center-periphery relation" in which "power is ontologically embedded" (31). Instead, it starts from the position that we must imagine something altogether different and continually think of other possibilities. To rethink the boundaries is to leave the problematic system intact, but imagining beyond is an attempt to leave the problematic system altogether. Slam and spoken word poets who search for something beyond are, on some level, always trying to move on to what is beyond, to what is on the horizon.

These poets are by no means the first group of artists to work in and toward something beyond. The black literary tradition rests on what Henry Louis Gates, Jr., and Nellie Y. McKay (2003) have called "the trope of the talking book." In their discussion of James Albert Ukawsaw Gronniosaw's 1772 autobiography, they cite the "repetition and revision" apparent at the beginning of the black literary tradition as well as how literacy has been, in many ways, synonymous with freedom. At the moment of its creation, Gronniosaw's text was "an unrelenting indictment" that spoke back to slavery, but with "a distinctively 'African' voice" it also "talked 'black,'" registering "its presence in the republic of letters" (xxxviii). Extending the trope to "Rethink Elocution," Dwight Conquergood convincingly argues that the embodiment of filched literature, or performance, allowed the white book to speak and speak b(l)ack, which was the "driving force behind slave literacy" (Conquergood and Johnson 2013, 118). In this way, the black talking book was always about imagining and creating something new, something beyond. This is not to suggest that the poetry slam is a black thing, as a quick survey of slam history and its national competitions will illustrate

otherwise. Rather, I travel b(l)ack through the black literary tradition because I am interested in the various ways in which blackness is performed and negotiated in slam and spoken word communities, and I believe that situating contemporary black poets in that larger tradition is both logical and useful.

According to Winston Napier (2000), "the Harlem Renaissance generated a literary and cultural explosion that would establish the black writer as a seminal social force" concerned with improving on and moving beyond sociopolitically crippling images of black folks—for example, Sambo, Zip Coon, Mammy, and others—that grew out of slavery. Theorizing how Alain Locke saw "the role of the black writer," Napier argues, "He understood it was to use art to represent blacks in a fresh light, a new 'racial utterance' functioning not only as a myth smasher but also, and more importantly, as a means by which to fathom how positive self-identity could be developed and regulated" (2, 3). This new racial utterance, grounded in a particular self-identification, was indeed a black agency beyond early twentieth-century politics.

The Harlem Renaissance's lack of a singularly defined form, style, or ideology generated debates about the movement's purposes and goals—among them, Langston Hughes's (1926) call for artistic independence in "The Negro Artist and the Racial Mountain" and W.E.B. Du Bois's (1926) resounding response, "I do not care a damn for any art that is not used for propaganda." There was even controversy around the term *Harlem Renaissance*.[4] Some black artists and intellectuals critiqued the movement for playing to negrophiles and other white audiences, and there were important discussions centering on whether or not the movement was simply adopting elite bourgeoisie white aesthetics that were far removed from everyday black life.[5] The era's black artists, however, charged themselves with the daunting task of defining "The New Negro." As the first generation to work toward performing themselves outside the purview of the white overseers, they understood that their work would be a foundation of imagining and working toward possibilities beyond that on which black artists would later stand.

The Black Arts Movement of the 1960s and 1970s shifted the roles of black artists, who "declared new aesthetic directives" because they believed that the Harlem Renaissance had failed to address the realities of everyday black people (Neal 2000, 3).[6] Members often dogmatically espoused a Black Nationalist rhetoric that was knotted to patriarchal and homophobic performances of masculinity, yet "caricatured versions of th[is and related] movements as fundamentally and unusually sexist distort them and the legacy of black women (and some men) who actively participated in them" (Smethurst 2005, 87).[7] Black Arts scholar-artist Larry Neal (2000) argues that the Harlem Renaissance failed because it "did not address itself to the mythology and the lifestyles of the Black community" (290). In other words, if the Harlem Renaissance can be read by the need to define the race, which was bound to issues of representation and a desire to show black folks in their best possible light to all people, then the Black Arts Movement can be seen as the need to set aside the need to dress up in one's Sunday best for white people in order to focus solely on the everyday lives of black people.

Phillip Brian Harper (1996) cautions against typical readings that pit the two movements against one another. Instead, he believes that members of both the Harlem Renaissance and the Black Arts Movement felt they were eschewing European influences to speak solely to and for black people.[8] Their historical repetition occurred "precisely on the basis of the perceived failure of the Harlem Renaissance to engage African-American interests" and, in turn, sparked a "Blacker than thou" rhetoric that created "social division within the black community" (46). As the aesthetic counterpart of the Black Power Movement, the nationalist, militaristic, and political strains in the works produced by the Black Arts Movement established a "black nationalist subjectivity" in which "the designation *black*" was no longer "a generic nomenclature by which any person of African descent [could] be referenced" (48, 49). While the Black Arts Movement artists were was undoubtedly "more forceful" than the Harlem Renaissance artists (Napier 2000, 3), they were so because their aesthetic was about "the destruction

of the white thing, the destruction of white ideas, and white ways of looking at the world" (Neal 1968, 2).

Closely following the Black Arts Movement both chronologically and conceptually, hip-hop was created in the 1970s by black and brown youths who were responding to increasing joblessness, the diminishing availability of welfare, and the loss of recreational facilities that had once served as platforms for voicing political frustrations.[9] They fit into the tradition of the Harlem Renaissance and the Black Arts Movement and should be critically discussed in the genealogy of black artists in the United States. This is not to suggest that these are the only periods in history that produced black art nor to claim that black artists moved neatly from one era to the other. Rather, these stages play particular roles in shaping cultural imaginaries as they pertain to the contemporary black performance poets whom I examine in this book. The new financial and political opportunities created in and by hip-hop spoke directly to how artists were imagining beyond. These disenfranchised black and brown youth used art as a backdoor means to engage with formal political systems that had never seen them as human beings. Given that hip-hop is discussed in "endless repetitions of silly, exaggerated claims" of materialism, sexism, and homophobia and that many black spoken word poets often say that their work responds to the perceived failures of rap, I believe it is apropos to assume that slam and spoken word poetry communities are progressive in ways that square with how they are depicted in popular discourses (Rose 2008 xi).[10]

Michael Eric Dyson (2003) argues that hip-hop was created in "bleak conditions" and questions flat interpretations of it in favor of more complicated understandings: "Rappers aren't *simply* caving into the pressure of racial stereotyping and its economic rewards in a music industry hungry to exploit their artistic imaginations," for "that is too narrow a measure for the brilliance and variety in Black art" (177, 179, 181). Dyson, much like Neal, believes that rappers are unfairly used as cultural scapegoats for America's gender and materialist woes. Neal (2000) writes, "To speak out against the gratuitous vulgarities of hip-hop is the easy part. The difficulty

comes in trying to do so while still affirming the aesthetic and cultural value of hip-hop" (128). Hip-hop was not created just as way to access capital; it is part of a richer history of black arts that questions and talks b(l)ack while seeking something new and beyond. Whether in the desire to assert one's own humanity, the pursuit of a different kind of aestheticism, or the establishment of new creative and political outlets, the black literary tradition—by talking black and talking back—has always concerned itself with this search. Although slam and spoken word communities are not entirely or historically black, they, too, are always searching for and working toward something beyond, often by working in these radical traditions.

In *Raising the Dead: Readings of Death and Black Subjectivity*, Sharon Patricia Holland (2000) discusses black literature, particularly Toni Morrison's *Beloved*: "[Its task] was to hear the dead speak in fiction and to discover in culture and its intellectual property opportunities for not only uncovering silences but also transforming inarticulate places into conversational territories" (3–4). By "raising the dead," black artists have not only disturbed the so-called finite boundaries of the dead and the living but also given rise to the possibilities of unsettling those in/of the margin and center as well as "the static categories of black/white, oppressor/oppressed, [thus] creating a plethora of tensions *within* and *without* existing cultures" (4). The slam and spoken word poets I study and study with use death and killing in our creative practices in ways that ask what other possibilities the dead might bear. Here, I am thinking about Sigmund Freud's (1918) "contemplation of the corpse," which gave rise to theories of the soul, the afterlife, reincarnation, and other possibilities beyond the flesh. Following Holland's (2000) concerns about the dangers in the dead and the living binary, one of which is that it sets the stage for all other binaries, I do not want to suggest that slam always reinforces the distinction between the dead and the living. Rather, I am arguing that slam and spoken word communities seek the help of the dead to disturb and reject existing boundaries and borders and to imagine new possibilities in the current modes of living.

Imagining beyond is not the same as invoking or communing with the dead, nor is death the only beyond that spoken word poets conjure. Rather, slam and spoken word communities employ death, one space beyond, as a metaphor or a catalyst for thinking about and working toward spaces and modes of living beyond our existing systems and structures. I am thinking here of death as the total and permanent cessation of all vital functions of a system or way of being in the world.[11] The poets in these communities who create oppositional and/or radical organizations are often less concerned about fixing oppressive structures than about creating space for something new, different, and beyond. In this way, slam and spoken word poetry, like performance more generally, are "poised forever at the threshold of the present," always an emerging, forever in search of something else or something beyond (Phelan 1993, 27).

To be a member of these communities is less about achieving a stable identity as a poet, a liberal, a radical, and so on and more about a commitment toward speaking a just and ethical world into existence and then working toward that world. The slam and spoken word poets I discuss in this book strive for the beyond in their "embodied commitment to a hypothetical present and possible future" (Batiste 2011, xvi).[12] These poets, with their radical belief in imagination, "take the stand that performance *matters* because *it does something in the world*" and that change requires the kinds of creative practices that exist beyond our current structures (Madison 2003 472).

Still, I do not contend that slam and spoken word poetry spaces are already beyond, nor do I want you to think that the salve for interconnected oppressions can be found solely within these communities. Indeed, the performance spaces I discuss, with their problematic power structures, often replicate the white supremacist capitalist heteropatriarchy that so many poets speak out against and work to destroy in their everyday lives. Moreover, slam relies on verbal language that "is at once controlled, selected, organised and redistributed according to a certain number of procedures, whose role is to avert its powers and its dangers, to cope with chance events, to evade its ponderous, awesome materiality"

(Foucault 1997, 216). This suggests that the move toward the beyond is bound up in the hierarchies and normatives that seem antithetical to much of the poetry produced in these communities. In *Decolonising the Mind: The Politics of Language in African Literature*, Ngũgĩ wa Thiong'o (1986) bids farewell to English because "language carries culture, and culture carries . . . the entire body of values by which we come to perceive ourselves and our place in the world" (16). For Ngũgĩ, writing in a neocolonial nation is a political act; and because culture is realized through language, using English, French, or other hegemonic languages supports neocolonial thinking. While there is subversive potential for the formerly colonized who choose to speak these languages, particularly in how they allow a global communication so that we may work toward anti-imperial liberation, slam and spoken word poets' reliance on them is further evidence of how difficult it is to move beyond imperialism, white supremacy, sexism, heteropatriarchy, classism, xenophobia, ableism, capitalism, and so much more.

Before 2013, many poets were unwilling to discuss the sexual assault that was happening in various slam and spoken word spaces, ignoring it in ways that were consistent with the U.S. justice system.[13] In addition to ignoring sexual assault, some poets worked to erase the bodies of color in slam. After the dominant success of black poets in both team and individual competitions, the national community responded with calls for "real poetry" that focused on writing. In forums and in everyday conversations, poets began vilifying those who relied on theatrics to win slams, while celebrating those who simply stood still and calmly read their work. In this way, they not only rejected slam's original desire to emphasize the performance of a poem but also attempted to remove the body from the slam. By suggesting that what the body offers is somehow less relevant than what the mind offers, this move toward "real poetry" erased the brilliant contributions of marginalized poets and championed older, disembodied poetic practices that had made slam necessary in the first place. In other words, not all poets and communities are progressive, and the label

progressive or *radical* can disguise the ways in which people fight for the liberation of one group while actively suppressing another.

The beyond, for all of its limitations, is grounded in a certain radicalism that recognizes that *progressive* is not a static identity construct but always a becoming, always a search for better ways of being, even as it is fraught with complex contradictions. In so saying, I contend that we are reading slam and spoken word poetry all wrong. The radicalism of slam and spoken word communities is located in our ability not to speak back to power but to imagine beyond traditional power structures even when we are caught up in them. It lies not in our desire to alter structures but in our desire for structural alterity in our ways and spaces, how we creatively and continually work toward beyond the beyond, wherever that is. It is here that we must begin to theorize and critique the radical potentiality of slam and spoken word communities and creative spaces more generally.

When creative writing programs saw us as illegitimate writers and rejected a great many of us early on, we trained ourselves. When the state defunded art and assaulted people of color's ability to creatively and critically engage the state, we created youth organizations such as SayWord LA, Young Chicago Authors, Urban Word New York, Get Lit, Brave New Voices, and other youth writer-performer programs that now serve thousands of young artists in and outside of school districts. When we could not secure book contracts because presses could not imagine how we would translate to the page, we created our own publishing houses such Write Bloody Publishing, YesYes Books, Button Poetry Books, and Penmanship Books. When agents, fearful of overly political voices, could not figure out how to market us to audiences, we created our own agencies such as DPL Productions and Layman Lyrics. In other words, we created alternative institutions. When we accepted "the death of art," killed the need for creative writing programs, and—because this is poetry—"s[a]ng with the whole body" (Johnson 2003, 202),we also killed the inherent need for publishing. Perhaps there is an irony or a justice in the fact that I am publishing this book about a community of writer-performers

who killed the need to publish by forging other, nonprint opportunities. Yet like me, many of the poets in these communities have also chosen publish, thus disturbing binaries and searching for something beyond them.

This is not a book about the dead, nor is it a comprehensive history of slam and spoken word communities. Rather, *Killing Poetry* is about performances of blackness, in all of our brilliant beauty and creative contradiction, and community-making in search for something beyond. It is a critical look at the ways in which slam and spoken word poetry communities "let go" in order to imagine something else (Wakefield 2011). Susan B. A. Somers-Willett's *The Cultural Politics of Slam Poetry* (2009), the first scholarly text on poetry slams and contemporary spoken word, also addresses the void of critical literature on the subject. Beginning with the premise that "marginalized voices—in particular, African American ones—are perceived as more authentic than other voices are at poetry slams," she focuses on black poets and how mostly white national slam audiences reward black identity performances at a higher rate because of a perceived level of authenticity (8).

It is true that white people are granted a degree of legitimacy and nuance and that black poets have to work harder for nuance so that we are not reduced to angry black poets, and this might account for Somers-Willett's authenticity claims. That said, *Killing Poetry* differs from her book in a number of different ways. First, whereas she concentrates on audience reception, I explore community negotiation so as to offer deeper insights into the politics of race performance within our communities. In other words, I recognize that the poets in these communities are larger than the sum of their performed poems. Second, Somers-Willett's text rests on false dichotomies between academic and so-called popular verse and between counter versus dominant culture, as if one cannot be simultaneously dominant and counter, or something altogether different. At the same time it flattens the complexities in the various performances of blackness. I believe "that whenever we are speaking of race, we are always already speaking about gender sexuality, and class" (McBride 2005, 58), so I

explore black women and men, black queer and straight poets to develop a more complex understanding of the slam and spoken word milieu. Finally, Somers-Willett uses authenticity discourse to explain why black male poets are more successful at poetry slams than other groups are. Given that she never offers the possibility that the black poets who won, and win, are simply better, her book at times reads less like a critical inquiry into why black poets are highly rewarded and more like a troubling racial apologia for the lack of white success. Couple that with her highly disputed argument that slam has "white, working-class roots" (2009, 12)—as if Marc Smith had never admitted he got the idea of competition poetry from the poetic boxing matches that were taking place in Southside Chicago in the early 1980s; as if Patricia Smith (a critically acclaimed black woman poet from the same neighborhood who got her start in the early days of slam) along with a number of nonwhite, working-class men were not helping to form the phenomenon since its beginning—it is hard to avoid the racial troubles in Somers-Willett's text. It is claims such as hers that led the New York–based poet Carlos A. Gomez to say in a 2008 interview, "Marc Smith is the Christopher Columbus of poetry."

Certainly, Somers-Willett (2009) deserves credit for having written the first critical text about this increasingly popular art form. Being a trailblazer, she was bound to make mistakes along the way. I, too, will miss steps, make mistakes, and leave gaps. Yet *Killing Poetry* hopes to be a substantial snowflake in slam's conversational avalanche. Beyond that, it is a book in search of a theory, grounded in social justice and equity, about what always might be; a theory that is as flexible and dynamic as the communities themselves. Holland (2000, 18) argues, "the dead acknowledge no borders," and slam and spoken word poets, with our proclivity toward death metaphors, attest to that disrespect. *Killing Poetry* works to understand the necessity and radical potentiality of that disrespect, which is grounded in a desire for that which is always beyond.

I take seriously Dwight A. McBride's (2005) claim that "it takes a multiplicity of genres—sometimes working together in the same essay—to effectively render the truth of our lives" (1). Throughout this book, I use a kind of methodological bricolage, combining critical ethnography, auto-ethnography, digital ethnography, performative writing, journalism, archival practices, literary analysis, rhetorical criticism, and others as I see fit, all braided together by performance theory. Saul Williams (1999), perhaps the best-known and most respected contemporary spoken word poet, has written, "this poetry / has become / about beauty / not about truth / the truth would have more questions" (70). Because the poets in slam and spoken word communities all write, perform, and think with poetry, prose, and everyday discourse, blurring methods and mixing methodological boundaries allow me to detail the dynamic happenings that occur within my sites and to ask questions that are as dynamic as the communities themselves. My approach is a means toward truths; it is about critical inquiry, a Foucauldian "genealogical" query that exposes how the power of politics and the politics of power affect our bodies and our everyday lives (Foucault 1997, 29).[14]

Truth telling is often difficult, and it is further complicated when you belong to the very community you are writing about. As a straight, cis-gendered, black, male, spoken word poet who actively participates in the national slam community, my status as a researcher and poet has been both beneficial and problematic. While some poets were extremely forthcoming with their narratives—as one black poet quipped, "This brotha is doing his thing, and deserves our help"—others were wary of how a black man who is questioning issues of race might problematically depict our communities. Worse, some were concerned that I might create racial, gendered, sexual, or class problems that they did not think existed or agitate political wounds they believed that their community was striving to heal. My black researcher body opened me up to some experiences while simultaneously closing me off to

others. Throughout my research, I was acutely aware of how my insider status as a home ethnographer carried social currency and baggage, but I was almost always praised for, as another poet said, "writing our story."

Thinking about telling our story as an opportunity, an honor, and an ethical responsibility, I was guided by D. Soyini Madison's (2005b) "moral obligation to make a contribution toward . . . greater freedom and equity." *Killing Poetry* begins and ends "with an ethical responsibility to address processes of unfairness or injustice" in slam and spoken word poetry communities. While most accounts of these communities gloss over how they, at times, produce and sustain arenas of domination, I go "beneath surface appearances," where most writers have stopped, to "disrupt the *status quo*, and unsettle both neutrality and taken for granted assumptions by bringing to light underlying and obscure operations of power and control" (5). I do this not because the problems in these communities outweigh their benefits but because I should, as the critic Gerald Graff says about theater and performance, "teach the conflicts" (Jackson 2004, 11). I keep in mind that good ethnographers should always be politically committed to doing the work of deconstructing oppressive power structures by telling difficult but always necessary truths.

Understanding that "ethnography is an *embodied practice*," as Conquergood eloquently argues, I have employed a particular kind of critical ethnography that foregrounds a performance-centered approach (Conquergood and Johnson 2013, 83). I have gone into performance poetry communities all over the country as a slammer, a featured poet, a fellow poet on the open mic list, and as an audience member. I have conducted interviews at open mics; in coffee shops, living rooms, and restaurants; via Skype and Facetime; or however both parties were comfortable. But these "were only the tip of a larger interactional iceberg that consisted of a deeper kind of 'hanging out,' a kind that blurred the lines separating fieldwork from friendship" (Jackson 2001, xii). Whether in Torung's, a late night Thai restaurant in East Hollywood, at one in the morning or at a poet's house while his or her children showed me their school artwork, I spent roughly nine years compiling more than one hundred

formal and informal interviews, dozens of group conversations, countless hours of performance watching, and everyday conversations with poets. As John L. Jackson has written, "fieldwork seemed a lot like living my life, only with a vague ethnographic agenda" (xii).

Recognizing the cultural capital afforded to performance and writing within slam and spoken word poetry communities, I made sure that I saw the performances of most of the subjects of my research. Likewise, most of them have seen me perform. I initially had to overcome my own ethnographic arrogance: that, as an active member of the community, I already knew what I needed to know to carry out this research. However, my arrogance had blinded me, leaving me both unable and unwilling to see and hear the power dynamics at play within slam and spoken word spaces. I eventually "realized how the ethnographer must be a co-performer" (Conquergood and Johnson, 2013, 92). That understanding opened up a space for me to be a part of, and not above, the community. It forced a certain cooperation and self-reflexivity on my part and allowed me to grow as an ethnographer and a community member. In this way, I learned that good ethnography warrants, even demands, a polyvocality.

As a commitment to this polyvocality as well as my general methodological ethics, I shared chapters with the people I interviewed so they could talk with me about how they and our communities would appear in print. At times, this was very rewarding, and the project became richer because of it. The performers both fact-checked and checked me, which in black vernacular means to put someone in their place. At other times, the sharing was difficult, when participants were slow to respond or changed their positions and politics after our interview. In other words, they are humans and did human things, which are often difficult for a static book to capture. I had to make tough choices about how to adequately and honestly depict my co-performers, many of whom I deeply love. Riffing on Conquergood's still apt and pithy claim in his oft-cited "Performing as a Moral Act" (Conquergood and Johnson 2013), this approach, one that attempted to include my co-performers in every

step, reminded me that opening and interpreting lives is very different when those lives are opening and closing your book.

Mapping the Text/Feeling the Terrain

Killing Poetry mostly follows my trajectory through slam and spoken word communities. Chapter 2 explores the conflict between two Los Angeles–based spoken word poetry communities, Da Poetry Lounge and Leimert Park, and the problems in their performances of black masculinity. Starting from the premise that DPL and Leimert Park are still male-centered and that a large number of these men are black, I turn to theorists whose work investigates the intersections of race and gender to answer questions about the Los Angeles slam and spoken word poetry community and new possibilities for black masculine performativity. Chapter 3 looks at the national poetry scene, focusing on the 2013 National Poetry Slam competition and a difficult but necessary meeting about sexual assault. The chapter is not about what constitutes rape but how communities are re/formed around difficult issues and about what happens when a community puts alternative justice methods into practice. In chapter 4, I move from the national poetry community to explore the virtual scene and the influence of Button Poetry. Working betwixt and between Diana Taylor's (2003) conceptions of "archive" and "repertoire," I critically look at the politics of virility and how black women, in particular, are being structurally denied a comparable space in slam and spoken word's digital archive. In chapter 5, I return to my time spent working with the youth poets in Chicago to explore what we might learn from our young people.

In many ways, *Killing Poetry* is about what compelled me to actively participate in DPL, and slam and spoken word poetry communities more generally, for fifteen years. It is about the vibrancy of performance poetry communities that literally and metaphorically save lives. *Killing Poetry* reads and riffs on the particulars of what allowed Fisseha "Fish" Moges and other black poets to say things in poetry spaces they "would deliberately sugar coat in a prayer," as he quips in his poem "For DPL." As sites of possibility, many slam and

spoken word poetry communities are invested in a critical search for an/other space, beyond the beyond, one that might be simultaneously nothing and everything, the outer even; one that might provide models for black folks to feel safe enough to do and say black things.

Far from claiming that the slam is, as many of my friends and family might say, "a black thang," *Killing Poetry* focuses on how black slam and spoken word poets navigate the diverse poetry communities in which they work. At the same time it critically examines how troubling racial politics shape these supposedly alternative spaces by narratively constructing those very spaces in a way that disallows blackness to operate in its full complexity. I am interested in how even in hostile spaces black folks still create ways, via performance, to not only "make do," as Michelle de Certeau and Steven Rendall (1984) might suggest, but to make different or at least "make it do better." In other words, I am concerned with how slam and spoken word communities limit and infringe on black performative expressibility and how the denial of blackness in these spaces opens up sites of generative possibilities for black poets. On a more practical level, I am concerned with adding to the growing discourse on how to help slam and spoken word poetry be the communities they desire to become.

It is my genuine hope that the reader comes away from this book not only understanding *Killing Poetry* and the poets who comprise the slam and spoken word communities but—as the black saying goes—"feeling it." To feel is to understand, but it is to do so with the body. I sincerely hope you feel our communities and our concerns, our passions and our politics. Even more, I hope you can learn from our magic and our mistakes. *Killing Poetry* was a labor of love, but a labor nonetheless—a work guided by a sense of ethics to help make these communities I love become as alchemic as they seem. And I hope you feel that.

2

"This DPL, Come On!"

Black Manhood in the Los Angeles Slam and Spoken Word Scene

I have said things in this room I would deliberately sugarcoat in a prayer.
—Fisseha "Fish" Moges, "For DPL"

In the spring of 2005, Da Poetry Lounge cofounder Shihan Van Clief released "DPL Anthem," the fourteenth track on his two-disc album *Music Is the New Cotton*. Fun, incisive, and brash, it unapologetically celebrates DPL, and it quickly became our song, serving as evidence that, "through anthems, the delineation between art and politics as well as listener and actor is blurred" (Redmond 2014, 2). The track featured founding and prominent DPL poets and rappers such as Sekou "Tha Misfit" Andrews, Adam "In-Q" Schmalholz, Gimel Hooper, and Lanny "Gaknew" Wilson. In the first verse, Sekou proclaimed, "Yall poets better watch your mouths," and the line rapidly became a declaration from every DPL member to everyone who was not. The hook, "This DPL, come on. Hardest in the game, ya'll can't fuck with us," and the verses that worked to ground that audacious claim, let everyone in the slam and spoken word poetry communities in Los Angeles and

beyond know that DPL was the best and was not ashamed to revel in that self-created label (Shihan the Poet 2005).

I have been a DPL poet for fifteen years, and I love the song and can recite it in its entirety. However, "DPL Anthem" is not without its problems. At times, the all-male track sounds less like a celebration and more like an invitation to a penis-measuring contest. The song features only men because in 2004 they were the best-known DPL poets who also rapped, but I cannot dismiss the misogyny, however clever the wordplay, in lines such as Gaknew's "If you don't like [DPL], don't come. That's what most pussies do" (Shihan the Poet 2005). While the song is no longer played at DPL and is now mostly seen as an amusing reflection of a past time, it remains contradictory in its attempts to empower even as it demeans both women and non-DPL poets.

Caught up in the tensions of possibility and problematic, the anthem can be seen as a symbol of Da Poetry Lounge and the performances of race, gender, and sexuality that form and inform community making. In many ways, DPL is more than a poetry venue; it is also a family, an institution, and a spiritual space. However, as Evelyn Brooks Higginbotham (1994), Victoria W. Wolcott (2001), and Marlon B. Bailey (2013) have shown, familial and spiritual spaces are not equally welcoming to all members. Many black male slam and spoken word poets in the Los Angeles poetry scene are caught up in a poetic fight, and at stake is masculinity and how it is constructed, reconstructed, and positioned in the community. This hetero masculine rift, sparked by antagonisms between DPL and the Leimert Park poets, has given rise to a series of exclusionary heteropatriarchal practices. Still, the fact that Fish, a long-time DPL family member, feels safer in DPL than he does in front of his own God suggests that the venue is a site of spirituality, as well as an institution and a family, and is always working toward something beyond.

Incorporated as a municipality in 1903, Hollywood, now the home of the American film industry, has become a metonym for entertainment and artifice. Crowded with tourists, star-lined streets, shops, landmarks, and sunshine, Tinsel Town can seem as magical and fabricated as the movies it produces. Its geographic

locale and association with the artificial have coalesced in such a way that many Angelenos feel that Hollywood both is and is not a part of Los Angeles. The performance artist Dan Guerrero spoke for many when he commented in his one-man play, *Gaytino!* (2006), "Hollywood, though only a thirty-minute bus ride, feels like a million miles away." Nonetheless, although many locals denigrate Tinsel Town, they continue to visit the district because it keeps producing groundbreaking entertainment outside of film. While spoken word performances and poetry slams were not created in Hollywood, they have become an important part of it. And on Tuesday nights, hundreds flock to DPL in Hollywood to see, hear, and feel spoken word and/or the poetry slam.[1]

It has been some time since I first wrote about DPL, and a lot has changed. Though it has always been a space in search of the beyond, we have begun to think about our family of performers in more inclusive and radical ways, which has also forced us to rethink the patriarchy that was once a defining feature of our venue. In this chapter, I highlight the inner workings of DPL and consider the contrasting approach of the Leimert Park spoken word community. I explore both their external conflicts, particularly their differing performances of black manhood, and DPL's own internal struggles with sexism and heterosexism. Along the way, I call on the work of theorists who investigate the intersections of race and gender to consider new possibilities for black masculine performativity.

Like all gender performances, black masculinity is a dynamic *"historical, ideological process"* that has no "intrinsic essence or . . . collection of traits, attributes, or sex roles" (Bederman 1995, 7). My exploration of the masculine posturing between the men of DPL and those of Leimert Park reveals a tense and troubled relationship between groups whose well-intentioned masculine performances replicate the oppressive structures they oppose. This chapter frames the black male poets of DPL's family as a manifestation of Mark Anthony Neal's (2005) *New Black Man*, the progressive and complex figure who recognizes that black gender performativity is fluid.[2] Yet they also illustrate how progressive masculinities not only reproduce oppression but often rely on problematic power

mechanisms to sustain so-called progress. In contrast, the young poets of Leimert Park exemplify what Neal terms the "Strong Black Man," the patriarchal male whose fixed performance of black masculinity limits him to the role of emotionless provider and protector. These two poetic sites allow me to advance Neal's idea of the importance of a new construction of manhood by black men, one that recognizes the essentialist snares of the "Strong Black Man" and simultaneously sees how the *New Black Man* negotiates the problematic history of its patriarchal predecessor. Even progressive masculinities replicate the power structures they claim to denounce, and this chapter suggests that in many cases the veil of progress both masks the lack thereof and also maintains troubling power structures. My goal is to tease out the tension between these two groups and their competing modes of black masculine performativity in search of something beyond the dichotomy.

It's a Family Thing

A lot has changed since I first began writing about DPL, yet it has always been a space in search of the beyond. As our family of performers has begun to think about ourselves in more inclusive and radical ways, we have also been forced to rethink the patriarchy that, at one point, was a defining feature of our venue. Originally called Dante's Poetry Lounge, it began as a weekly poetry reading held in Dante's living room. As the event grew too large for Dante's home, the founding "four brothers" held meetings to discuss the responsibilities of the increasingly popular venue. For two years, they moved DPL from place to place, eventually finding a permanent home at Greenway Court Theatre. Now approaching its twentieth anniversary, DPL is one of the longest-running spoken word venues in the nation, behind only the Nuyorican Poets' Café in New York, the World's Stage in Los Angeles, and the Green Mill in Chicago, all of which have been in operation for more than four decades.[3]

DPL is a hub for many slam and spoken word poets and poetry lovers in southern California, attracting a wide variety of

ethnicities, ages, and class backgrounds. It is a performance site where culture is made, enhanced, and troubled. Shihan, Poetri, and Dante all claim that *Def Poetry Jam* got its start after the producers Stan Lathan and Russell Simmons visited DPL. While Stan does not confirm their story, he also has never denied it. In an August 2009 interview, he told me, "We were thinking of doing a poetry show for a bit. We went to a few spots around the country. We definitely went to the Lounge and got some ideas."

Reflecting on the alchemy of the space, Darnell "Poetic" Davenport, a former gang member, told me in August 2008, "The Lounge literally saved my life, and I'm not just saying that to say it. This poetry stuff really saved my life." He began writing in 2001, at the age of fifteen, in order to escape and confront the harsh realities of gang-ridden South Central, Los Angeles. Poetic is a dark-skinned young black man with cornrows and unusually long fingernails. In his fitted baseball cap and skinny jeans, he is a beautiful cross between gangster and hipster. His work, largely autobiographical, covers gang life, his brief incarceration, the young woman who, he told me "chose to abort [their] child," hip-hop, and politics. His signature piece is a poem about finding ways to love and appreciate his mother and her womanness, despite the fact that, in his view, she left him for drugs. Beyond its specific subject matter, the poem is a general call to women, asking those with low self-confidence to recognize their brilliance and strength, proclaiming, "you are woman / beautiful / so act like it." Poetic was once a member of the Inglewood Family Bloods, so his willingness to openly display his pain counters not only the militant, stoic, and unaffected "strong black man" stereotype but also the stoic and nihilistic black gangster image. "This is how poetry saved my life," he told me in our interview. "It gave me a way to get a lot of stuff out, stuff that was just bottled up, . . . shit that I have not dealt with, . . . and the Lounge was a huge part of that."

Speaking about DPL's ability to be a home space for so many different people, Shihan told me in 2008, "That's why the Lounge has the success it does, because the poets are able to [cover all topics] and say something for everybody." He talked with me about

topics that are frequently covered in poetry slams and the ways in which they may lead to oversimplifications about what kinds of poets and styles constitute a slam:

> Yeah, everyone sticks to what they do. So you get the race . . . race, gender, . . . economic status, [and] all those things become things everyone just talks about and you don't get much variety on the national scene. And when you do, you get "Oh, shit! That was fresh. Did you see that?" But for the most part . . . I mean, I've heard some black poems, and some being gay poems that were dope . . . and no matter what you are, you can enjoy that piece right there. That is dope . . . no matter who you are.[4]

It is interesting enough that a heterosexual black man, a prominent member and cofounder of DPL, can outwardly express appreciation for "being gay poems," despite the heterosexism in the Lounge. But what makes Shihan such a dynamic figure is the way in which he publicly loves his family and how he places that love above all. In his poem "Father's Day," he responds to someone who once told him, "You remind me of God," by saying, "The only thing God about me is my family." In his poem "Trinity," he confronts his wife's family and the ways in which they chastise him for not being Christian: "If God is love, then tell me why is my God not good enough for you?"

Shihan is brash and unapologetic, blatant and brutal in his honesty, amazingly funny, and one of the smartest people I know. When he loves, he loves hard. He is my mentor, my unofficial big brother, and one of my closest friends. He is, without doubt, the most important person in DPL, the only one who has consistently hosted it since its beginning. He has seen generations of poets come, grow, and go, and the current generation affectionately calls him "Papa Han." Shihan is a slam and spoken word historian. He has coached six teams to finals, appeared on every season of HBO's *Def Poetry Jam*, taken part in numerous documentaries and national commercials, created a poet agency, mentored poets as they build youth organizations, and so much more. The fact that he has participated in many poets'

weddings is a testament to his importance. I called him so often while writing my dissertation that he might as well have been on my committee. If E. Patrick Johnson was my field advisor, then Shihan was my advisor in the field. To see and hear him read a poem about his wife or their children is to experience a black man at his most vulnerable and most powerful, and to be reminded of the transformative possibilities of performance.

Poetic and Shihan are not the only black men in DPL who openly display their emotions in ways that are inconsistent with the stereotype of the strong black man. The Lounge's resident DJ, Gimel, shares poems that champion a more peaceful world, and Rudy Francisco composes feminist poems. They and countless others have challenged the narrow definitions of black manhood. Like Poetic, who uses his poetry as a tool to heal himself emotionally, and Shihan, who shows "another kind of black man who can let go" and be vulnerable, many DPL poets see the Lounge as a space to freely express themselves. The space, as Gimel told me in a 2008 interview, "really can save somebody's life, brotha."

DPL has also allowed people to create meaningful and lasting relationships. As family members do, Lounge poets house one another, refer to each other's children as nieces and nephews, and offer support and feedback. They call one another brother and sister. Countering the idea that we do not get to choose our own families, we have been in each other's wedding parties, attended the birth of children, and, importantly, been there for those of us who have decided not to marry or have children. We have helped each other move, taught one another how to write and perform, provided financial support, flown out of town to offer emotional support, offered a welcoming space, and carried out countless other acts of kinship. We pick up whenever and wherever biological families leave off and, in some cases, supplant them entirely.

Yet as the poet Natalie Patterson told me in 2008, "I like that when I go to the Lounge it feels like home to me, but it's suspect on some level." Natalie is among a long list of women who at various times have kept DPL going by managing finances, public relations, and general organizational issues. However, she struggles

with its contradictions as a place that brings together remarkable people while masking its exclusionary practices with progressive poetics. She said in our interview, "It's a boy's club."

Bridget Gray, the only woman to become a two-time Grand Slam Champion—back-to-back for both L.A.'s and Hollywood's slam teams—is a nationally recognized poet who, in her own words "is half black/half white" (as she notes in her unpublished poem "Half"). She has been a part of the DPL family longer than I have, but she has so many problems with Shihan and Poetri that she no longer visits the Lounge. In fact, she would probably resist being identified as part of our poetry family. She has declared both publicly and privately that both men have unfairly kept her from winning slams and making money because she is a strong woman.

One particularly disturbing story reveals the complex clash of gender and race. "Andrea," a young white DPL poet, was beaten by her then-boyfriend, "Jerry," a fellow DPL poet and a black man. She told me that, instead of holding him accountable, another male in the DPL family, "Peter," had had the audacity to ask her to leave an open mic because the situation was still sensitive. Peter, however, told me he had asked her to leave because he felt that she was there only to agitate Jerry, who was a featured artist that night, and exacerbate the messy situation. I was later informed that Andrea had used "nigger" (maybe even "nigga") in their arguments with each other. Though her use of the word remains murky, it is clear that unresolved race issues had complicated the tumultuous relationship.

Clearly, such collisions of race and gender should force DPL poets to raise questions about the politics of language, cultural access, and privilege. Poets who use the Lounge as a space to share personal material must take responsibility for what happens on and off stage. While DPL is a presumed safe haven, it can also be a messy, complicated, and hurtful interface between public and private performances. For many family members, supporting Andrea and condemning domestic abuse meant disavowing Jerry yet condoning racist actions. On the other hand, supporting Jerry and denouncing racism meant backing domestic violence. But far too many of us stood idly by, and Andrea understood our strategic

silence as a vote for Jerry. Not disguising her disappointment, she asked me during our 2008 interview, "Where were you all at?" Astounded and confused, I had no answer other than an apology that was far too late, but the conversation did force me to question just how open open mics are.

In *The Will to Change*, bell hooks (2004b) writes about the psychology of male violence: "Patriarchy demands of males [that] . . . they engage in acts of psychic self-mutilation, that they kill off the emotional parts of themselves" (66). A strict code of silence works alongside this culture of violence, for "to be true to patriarchy we are all taught that we must keep men's secrets" (56). Rather than denouncing white supremacist heteropatriarchy, black male silence and its concomitant disavowal of equity and equality reinforce it in hopes of gaining favor from the dominant order. This is exactly how straight cis-gendered male privilege works: not simply in my ability to freely and fully navigate DPL, unaware of and unconcerned about the safety of Andrea and other women, but in the way in which blind spots are preferable and even strategically chosen. In other words, privilege is the power and the comfort of not having to know as well as the comfort of choosing not to know while feigning ignorance for reasons of self-interest. Such thinking and maneuvering are selfish and unimaginative and do nothing to dismantle problematic power structures that rest on pitting oppressed groups against one another. We have to think about and work toward collective solutions.

Though the Lounge is open to women, most of the performers are men. Slam has, as Marc Smith remarked during our 2006 interview, "become a man thing." In an attempt to counter this boys' club image, DPL began hosting an annual women's night. Now, on one Tuesday in October, only women host and read poetry. This is not a solution, but it is a step—though it is certainly not enough to correct or even offset the sexism and patriarchy that have become integral to DPL. The off-night, which operates as a counter-space, suggests that that male control is the natural and normal way of operating: it reinforces the male-centered power structure it claims to oppose. Still, the night is a celebration, however shortsighted,

of the long list of accomplished and brilliant women poets in the Lounge's family and the Los Angeles poetry community, many of whom rarely come to DPL otherwise. The men of DPL take the back seats, and our sisters perform. It is the one moment of the year when we aren't asking, "Where are all of the women?"

Yet many men of the Lounge refuse to admit that it is a boys' club. They are even more troubled about the idea that they may have played some role in making DPL unsafe for women. During my group conversation with Adam "In-Q" Schmalholz, Poetri, and Shihan, all three insisted that they encourage women's participation. It is true that Shihan does tell his weekly audience that it is important to see more women perform on DPL's stage. Nonetheless, our best efforts have resulted in one women's night per year, and we have little history about the women who have been instrumental to DPL's success. In her interview, Natalie Patterson concurred: "Women's night is great, but there needs to be more. There needs to be something where the Lounge's story is told, including the women who, at times, kept it running." She mentioned Poet Ronnie Girl, whom the four co-founders credit as influential on their own performance poetry. While Natalie agreed that Shihan has spoken about how important Poet Ronnie Girl is to him personally, she believes that Poet Ronnie Girl should be lauded for her larger importance to DPL. In our discussion about the cultural capital attached to the four co-founders, Natalie also asserted that Justine Bae, Nafeesa Monroe, and she herself—all of whom have kept the Lounge afloat—should not be forced behind the scenes in the retelling of DPL's history.[5]

DPL continues to struggle with its own patriarchy and sexism. Yet despite our shortcomings and shortsightedness, many of the Lounge's male poets have taken steps to make our venue a safe space for all artists. Shihan has promoted Natalie and Jasmine Williams as women hosts and Edwin Bodney as a queer male host. He and I have mentored many women and queer poets, and we recently turned the slam team over to the guidance of Alyesha Wise. Poetri has consistently worked to open up opportunities for women poets in the entertainment industry, including getting

a nationally aired commercial for KiNG, a gender-fluid bira-cial woman. Gimel Hooper talked to me about giving up his DJ responsibilities to a woman, but she moved away from southern California before he got the opportunity. All of the DPL hosts celebrate the diverse staff that includes women and queer folks and, in many ways are, working to do better.

Got Beef

Nonetheless, patriarchy continues to flourish in the region's slam and spoken word poetry venues, partly because of the testy relation-ship between the men of the Lounge and Leimert Park's spoken word community. Developed in 1928, the neighborhood known as Leimert Park now boasts one of the largest concentrations of black middle-class people in the United States. But it was originally established as a white-flight exurb, as white people shifted from the East Side of Los Angeles to the West ("Leimert Park" n.d.; *Leimert Park Village* 2016; Sides 2006). The filmmaker John Sin-gleton has called the neighborhood "the Black Greenwich Village" (Gluck 2006), and its tree-lined streets and manicured lawns com-bine the aesthetics of East Coast suburbs and those of West Coast sprawl. Leimert Park is a regional center of African-American art, from blues and jazz to theater and hip-hop (Gluck 2006). The neighborhood has also been a fertile site for poetry venues such as 5th Street Dick's Café and the World's Stage. As with most scenes, the neighborhood's poetry venues have emerged, collapsed, and popped up again, and many exhibit an African-centered black nationalism reminiscent of the Black Arts era.

However, despite its idyllic setting as a poetry scene, Leimert Park poets are stuck in time. Following the philosophic doctrines produced by the Black Arts Movement, many of these young poets often perform black nationalism by wearing kente cloth and col-laborate with Djembe drummers in venues that smell of burning incense. I understand the need for some African Americans to mimetically connect to an Africa we were violently taken from, and the performances of those desires are in many cases quite beautiful.

But some of these poets treat their work as "a corrective" to all of the problems that face African Americans, and that attitude is shortsighted, pompous, and problematic (Gayle 2000, xxiii).[6] In a 2009 interview, the Leimert Park poet Sadiki Bakari told me, "In order to be the gods and goddesses we are, we need to get back, to find our true Africanness. We lost that." Sadiki is a smart, self-taught brother who can quote almost any expert in the African diaspora. He seamlessly switches from hip-hop gear to dashikis to a black nationalist aesthetic and, like the scholar Molefi K. Asante, believes that Afrocentricity is a "transforming agent," a "rediscovery" (1980, 4). When he agreed to our interview, he jokingly asked me, "You ain't afraid to come back to the hood, are you?"

I replied, "Nah, bruh. I stay in the hood like underfunded schools."

"And ain't that a real problem?" he said. We laughed and decided to meet at an Afrocentric café in Leimert Park.

The neighborhood's poets are not the only group to perform Africa, but their dogmatic belief that we are all "involved in a black-white war over the control of [black] image[s]" sets them in stark contrast to many DPL poets (Gerald 1969, 45).[7] "Lounge poets," Sadiki told me, "don't care how the media make black people look, but we do." Given DPL's diversity, many of its poets see race as more complex than a black-white binary, and others consider it a peripheral issue. As a result, Leimert poets tend to label DPL poets as sellouts or race traitors, and DPL poets tend to label Leimert poets as extremists and fools.

I want to be clear that I do not read Afrocentricity as mere foolishness but as "the belief in the centrality of Africans in postmodern history" (Asante 1980, 9). It is "a collective memory of the continent," where those throughout the diverse African diaspora participate in an "African cultural system" in ways colored by their own particular histories and locations (16). Leimert Park's Afrocentricity is a strategic choice to claim an African-centered agency in order to achieve sanity in a maddeningly white supremacist world. Yet rather than accepting this necessary reassertion of Afrocentric agency, DPL poets often arrogantly and problematically mock Leimert Park poets. Following the logic of Charles E.

Walker's (2004) well-known response to Asante, many insist that Leimert poets are wrapped in essentialist "mythology" (3). Perhaps the DPL poets, as Asante (2007) wrote of Walker in *The Afrocentric Manifesto*, are unable or unwilling to fathom that "a theoretical idea, based on African traditions and concepts, could exist apart from the European experience" (4). In short, while some of their criticisms are valid, DPL poets must not be so quick and willing to throw the baby out with the bathwater.

Still, as Shihan told me during our 2008 interview, "I don't go there. I don't even feel I write enough revolutionary . . . or Afro-revolutionary poems." In my 2008 group conversation with a few DPL audience members, one young woman said, "I go [to Leimert Park] every now and then, but I feel like I'm being yelled at to join the revolution. What revolution? I don't know. But they yell at you more than your average poetry spot." Shihan joked, "I'm down with the revolution and all, but it can't be all angry. It has to have some fun in it. Because if it's all angry then I can't be a part of it."

In his poem "Another Day," which I heard him perform at a poetry showcase in Los Angeles, Sadiki made a move straight out of the Black Arts handbook:

America persecutes me.
And asks me to salute a racist flag,
salute start that enslaves oppression,
and oppression enslaves slaves,
represents stripes that mark welts on slave laborers' backs,
backs that be whelped and whipped.
Soil blistered my ancestors' feet,
feet that slept for years.

It's a honky on my shoulder
shall I kill it?
I said,
it's a honky on my shoulder
shall I kill it?[8]

There is a general sentiment that African-centered revolutionary poetry has its place. But as Phillip Brian Harper (1996) writes of the Black Arts movement, its problems are in its seeming inability "to postulate concrete action beyond 'black rhetoric,' to project beyond the call manifested in Amiri Baraka's 'SOS'" (46). Moreover, its revolutionary call back to the 1960s risks producing a poetry community destined to repeat the polarizing mistakes of its poetic past. Black Arts poetry often narrowly defined blackness and constructed an us-versus-them logic, thereby fashioning some black folks as authentically black and others as inauthentic at best or white conspirators in dark skin at worst. Harper (1996) claims that because the second-person pronoun "conjures an addressee to whom the iteration is directed, the invocation of *you* also necessarily implies a producing source of that iteration—namely, an *I*—against which *you* itself is defined" (47). In other words, the *I* who calls for black consciousness must, by default, already be conscious. And because *I* have linguistically set myself up against *you*, *you* are not authentically black or conscious.

The work of the Leimert Park poet Tony B. Conscious echoes this style. In addition to writing, Tony B. travels the country selling his t-shirts and paintings, which almost always feature a historical black figure or a call to Africa. In a blog post, "Pan African, or 'Slam African'? This is the Question . . ." (2007b), he took issue with the Magic Johnson Pan-African Film Festival for contracting Shihan to host the poetry segment of the month-long event. Suggesting "CORPORATE SPONSORSHIP and the HOLLYWOOD MINDSET has seeped into the cultural fabric of the festival," he argued, "most PAN AFRICAN poets cannot even get on the bill," and "the majority of the performers are SLAM poets who are friends of the host and don't live, nor take part in the community in any way, shape or form."[9] Furthermore, he declared, "SHIHAN IS NOT PAN AFRICAN." In fact, many DPL poets do live in Leimert Park. But Tony B.'s discourse, much like that of the Black Arts era, establishes an *I*-against-*you* world in which slam poets cannot be pan-African and vice versa. According to many Leimert poets, so-called real

blackness cannot be attained until the black men of DPL adopt Black Arts politics. In Tony B.'s eyes, the mere presence of DPL "mildewed the once sweet frankincense and myrrh aroma" of the event.

Sadiki agreed. In a comment on Tony B.'s post, he wrote, "I will continue 2 manifest Pan Afrikanism and continue to do justice to the ancestors who have paved the way. I only hope those who compromise themselves and their art soon rise to the god and goddess state that exist within them because at some point the sharpest power of my tongue will be forced to cut through any falsehood that desecrates the art . . . the ancestors will continue to use me as a vessel . . . war has been declared on our humanity, art, history and our moral fiber as Afrikans." Both he and Tony B. have made it clear that poets "who compromise themselves" are neither true poets nor real black people. In another blog post, "If Langston Hughes Were Alive, Would He Slam?" (2007a), Tony B. fashioned slam, *Def Poetry Jam*, and DPL as an axis of evil. While he never directly called out the Lounge, he did decry "step and fetchit spittas slanging words about fried chicken, watermelon [and] Krispy Kreme Donuts." The fact that Poetri has a well-known poem about his own eating issues in which he jokingly argues that Krispy Kreme Doughnuts used to be Krispy Kreme Kroissants (KKK) suggests that Tony B. was clearly marking him—and perhaps other DPL poets—as modern-day Stepin Fetchits—blackface performers dancing for the approval of white people.[10]

In a move similar to Baraka's, Tony B. (2007a) has pleaded for "house niggahs [to] call 'HOME,'" thus entrenching the myth that some poets live well inside the big house with the master while others, like himself, work hard in the field. One of the t-shirts he produces proudly reads "Son of a Field Negro," and in fact many Leimert Park poets now call themselves field poets. Yet his blog post, and the accompanying comments of his fellow Leimert poets Sadiki and Nikki Skies, completely overlooks the struggles of many house slaves as well as the complex choices of many black performers in blackface. He assumes that because of

the financial, slam, and entertainment industry success of DPL and its poets, the venue's black poets have selfishly or carelessly chosen to live in the big house, forgetting their blackness in an attempt to gain the master's favor. In other words, many Leimert poets feel that DPL poets have sold out. And because DPL is much more diverse than Leimert Park is, especially in terms of race and class, the critique of selling out is particularly geared toward the Lounge's black family.

Yet DPL is not innocent an innocent victim of Leimert's bile. Many Lounge poets view the contemporary Leimert poets as foolish and less accomplished. In his poem "Negro Auction Network," Shihan mocks poets who perform "African." Taking on the persona of a young black Afrocentric poet, he states:

> My niggas
> Life is hard
> It's a struggle being a Black man
> Cause Black means hard
> And hard is life
> So Black must also mean life
> But it also means royalty
> Cause we were all kings and queens before we was slaves
> My Black African Goddess sister Nubian queen
> Ashay
> I will never disrespect you
> I love you
> You're not a bitch or a ho
> Power to the people
> In Shaa Allah
> Ashay

This kind of mockery, though humorous, relies squarely on caricature. The poem lyrically suggests that many overly Afrocentric black male poets are buffoons who spout misguided rants about race and racism.

Nor I am innocent. My own unpublished "Black Poem" states:

This poem
Is some really, really Black shit
I'm talking Africa Black
I'm talking give me my diamonds
My gold, my land, my freedom
My happiness back Black
This poem is somewhere between 11:59 p.m. and 12:00 midnight
 Black
They are not enslaving our bodies but our minds Black
I'm gonna end every line with Black . . . Black

* * * * * * * * * * * * *

This poem is so Black
That it says the names of a few African gods
Particularly some names you know
Like Oshun and Eshu
And then I trail off to a few that I made up
Like Igbabo and Shalaza
And you'll think you don't know those gods cause you're not
 Black enough . . . Black

While neither of these works was written as a direct attack on
a Leimert poet, it is difficult not to see them as critiques of black
nationalist discourse and, by extension, of Leimert Park poetry. Our
arrogant they-should-become-better-writers attitude has wors-
ened the situation and has revealed a hierarchy that is something
less than critique. Both Shihan and I struggle in the space between
the intentions of our pieces and the problems they may cause. Not
only can the poems be read as our (and DPL's) indifference to
race struggles, but they also fashion creative black radicalism as
foolish rhetoric in ways that are consistent with white supremacy.
Such intent could not be further from the truth, but our pompous
stance has, at times, made constructive conversation between the
two communities almost impossible.[11] There is space in slam and
spoken word communities for play—particularly wordplay—but

for many in the Leimert Park poetry community, our mockery of "Afrocentric speak" also mocks black critiques of racism and black subjects as legitimate political and poetic agents. Sadiki told me, "I guess [the poems] are funny to some people, but racism and race liberation is a serious business." He believes that our poems give "some people"—that is, white people—license to laugh at black men who are "trying to do positive things for our people."

Underlying our mockery, however, is a stronger critique of the masculine performance, one that centralizes Africanness as a stand-in for masculine bravado, and this operational logic is highly problematic. Acutely aware of the history of black masculinity and how black men are viewed and portrayed, the black men of both DPL and Leimert Park are heavily invested in performing variations of black manliness that trouble the stereotypical constructions of themselves. Whether openly discussing their emotional selves by displaying love for and commitment to family or by engaging with 1960s-style black militarism, they both work to perform a black masculinity that counters the images of stupid, lazy Stepin Fetchits or the endlessly popular gangsters of the entertainment industry. In other words, both groups perform their versions of real black men to offset reel black men.

Given how the legacy of nineteenth- and early twentieth-century minstrelsy continues to haunt black bodies, it is no wonder that so many black slam and spoken word poets are prone to quickly mark each other as poetic shufflers concerned only about the approval of white people. Likewise, depictions of hip-hop as nothing more than grotesque violence, reckless consumerism, and hyper-objectification of women demonstrate that images of black men in pop culture have always been unsettling. Here, where the images of black men are made and remade, the black men of Leimert Park and the Lounge launch their poetic fights. But their conflicts are more than disagreements. They feed into oppressive power structures that are served by pitting subjugated groups against one another and thus blocking the coalitional work necessary to push back against those governing powers. Whereas Leimert Park poets are calling for the "Strong Black Man" that

Mark Anthony Neal (2005) critiques in *New Black Man*, DPL wants a more encompassing black man who is not obsessed with the kind of revolution that drives Leimert Park poets but is still invested in sexist and heterosexist patriarchal control.

Neal (2005) writes, "The 'Strong Black Man' was conceived as the ultimate counter to the distorted images of shiftless, shuffling, threatening, and dangerous black men that populated virtually every facet of American public and commercial culture" (25). As a response to the notion that black men are lazy boys, this archetype of the responsible, emotionless, hardworking family provider and defender has good intentions. Unfortunately, he reinforces "a rigid model of black masculinity that allows for little if any flexibility" or critique (27). Now that his figure has become embedded in "our mythical Black nation," acknowledging his shortcomings is viewed as a way to "attack the very foundation of the black nation. Even worse, it is an attempt to collude with our enemies to bring down the race" (24).

Furthering this discussion in terms of authenticity, Harper (1996) also argues that black folks are marked and remarked as masculine to the exclusion of black women, black queers, and, at times, middle- and upper-class blacks. In his view, "racial identity [and] . . . 'authentic' African-American identity in particular—can be, or effectively *is*, gendered-coded specifically as masculine" (103). The performance scholar E. Patrick Johnson (2003) adds, "Black authenticity has increasingly become linked to masculinity in its most patriarchal significations" (48). Both Harper and Johnson assign the anxiety surrounding black masculinity to "paranoid racial and sexual fantasies" (Harper 1996, xi), and that phantasm often results in rigid notions of what constitutes black manhood.

But black men with more flexible modes of masculine performance face social and physical lashings. According to Neal (2005), these "New Black Men" are "brothas" who are "willing to embrace the fuzzy edges of a black masculinity that in reality is still under construction." The New Black Man is "complex" and "often contradictory," but his performances of "progressive" masculinity are those "that most 'Strong Black Men' would consider the politics

of a 'punk ass'" (29–30). However, being called a "punk ass" is one thing; being violently treated like one is another. As he "struggles with living up to the progressive," the New Black Man's gender politics break tradition with the old Strong Black Man (30). In this space, somewhere between progressive and regressive, the black men of DPL understand "that *New Black Man* is a metaphor for an imagined life, one that [we] fail to live up to everyday" (xx). Despite our sexism and homophobia, we try "to create new tropes of black masculinity that challenge the most negative stereotypes associated with black masculinity . . . largely created by blacks themselves in response to racist depictions of black men" (xx–xxi). We try to be better black men than earlier generations were, to provide alternative images of what has historically been given to us.

Shihan, Poetri, Gimel, and Gaknew, all of whom are incredibly active in their children's lives, force us "to reconsider what roles [black] fathers play in the parenting process" (Neal 2005, 101). Their everyday performance of father, as well as their poems and stories about fatherhood and marriage, challenge myths of both the absentee black father and the father who is a man simply because he provides. Moreover, all four men have daughters, and all four have told me, on different occasions, that raising young girls has, as Poetri put it, "completely changed [them] as a man." After reading a touching poem at the Lounge in front of his wife, Elsie, and their daughter and son, Shihan, wiping tears from his face with the assistance of his four-year-old daughter, told the audience, "I just want to provide another image of black fathers, of what black men can be."

Shihan's ardent performance is a clear break from the dispassionate Strong Black Man. And he is not alone. Poetri cried on DPL's stage while reading a poem about his wife's struggle with multiple sclerosis and what that means to their daughters. Gaknew broke down while performing a poem about his wife's near-death experience during the birth of their child. These men poetically imagine "a world in which [their daughters] can be empowered to be the kinds of women—people—they wish to be without the

constraints of sexism, misogyny [to an extent], homophobia, and racism" (Neal 2005, 119). They desire the kind of world in which their daughters can, as Shihan states ironically in "Father's Day," make "mountains out of molehills." All four men answer Neal's call for a "black feminist fatherhood," one that is more than just about "little black girls seeing their fathers as strong, protective, and responsive to their needs . . . but . . . that attempts to embody, to the extent that a man can, the realities of being a young black girl and woman in American society" (113).

On the other hand, the Leimert Park poets Sadiki and Tony B. still insist that so-called real black manhood, and by default black fatherhood, is solely about displaying unwavering strength and providing for a family. Although both roles are essential for parents, their subscription to the inflexible performance of the mythical Strong Black Man "champion[s] a stunted, conservative, one-dimensional, and stridently heterosexual vision of black masculinity that has little to do with the vibrant, virile, and visceral masculinities that are lived in the real world." While the black men of DPL struggle with their issues of masculine privilege and, on some level, attempt to perform more encompassing black masculinities, the black male poets of Leimert Park are "unrepentant in their sexism, misogyny, and homophobia" (Neal 2005, 24). As Tony B. (2007a) reiterates, "In a Black man's mind we will find our greatness." He never allows that greatness might be found in the minds of black women or children.

The masculine posturing between the two groups seems inevitable precisely because of the continued threat to black men. The physical, mental, and emotional pain they must negotiate unmakes black masculinity even as it is being made; it creates the real need to erect a Strong Black Man who can withstand and fight against it. Moreover, the needs and desires of black men to both protect and project themselves in better ways perpetuate competing black masculinities in which the Strong Black Man is too rigid and the New Black Man, as promising as he seems, is difficult to maintain. If we see racism, sexism, homophobia, and others as interconnected oppressions, then we can say that both DPL and the Leimert Park

poets replicate and reinforce racism in their desire to perform corrective masculinities, mainly because their performances cannot escape the carceral logics that trap them in what Jeffrey McCune, Jr., (2014) calls "the architexture of black masculinity." Constraining black male possibility, it illumines "how space (the physical frame) and the texture of space (the ideological frames of gender) can create a vernacular of . . . what constitutes appropriate gender presentation and sexual behavior" (16). McCune's words aptly unpack the ways in which institutional, communal, and personal surveillance work on black masculinity to the point that queer subjectivities are, in some ways, precluded in favor of something more "appropriate." Even within the desire to find healthier and more inclusive possibilities, these poets, reliant on male-centered solutions, are not searching for better possibilities but are fighting over options, and their myopia forecloses the many performative possibilities on the horizon. Both DPL and Leimert Park attest to the need to continually work toward multiple, flexible, and fluid modes of black masculine performativity—not something new or strong but new *and* strong, and something altogether different that recognizes the so-called grey areas: the fact that black manhood must not be protected at the expense of women, children, and queer folks; that masculinity is not the domain of men. Black masculinities, grounded in an ethics of care and love—that, I believe, is not about sainthood or a canonization of a particular mode of being but about the continual work for better, healthier, and more inclusive possibilities.

No Homo, but Definitely Queer

In the early years of the twenty-first century, many young men would insert "no homo" into conversations whenever something was said that could even remotely be construed as gay. For example, I might ask a male friend, "Could you give me a ride? No homo." The phrase was supposed to be a buffer against the sexual connotations of *ride*, yet the line between things that were gay and things that were not remain unclear. The "no homo" phenomenon

was so widespread that in some cases it became ubiquitous. The Harlem rapper Cam'ron (2007) commented on Hot 97, New York's famous hip-hop radio station, "Like with me, like . . . even . . . no homo is just basically installed in my vocabulary now. So it's like even if I'm in a meeting, I'll be with my lawyer and might just say something and be like 'no homo.'" Heterosexual men and others used the phrase to shore up queer slippage and seepage during homosocial moments. As Cam'ron (2007) said, "This isn't about being gay, it's about saying something gay. . . . This is about saying gay things by accident, no homo. This isn't about persons really being gay. You know that they are not really gay." The term provided an emergency verbal stand-in for the not-present woman in the "male-male-female erotic triangle" and concretized the "special relationship between male homosocial desire and the structures for maintaining and transmitting patriarchal power"—at the expense of homosexual men (Sedgwick 1995, 25).

I talk about "no homo" in the past tense because, like many slang phrases, the term had a short shelf life and is rarely used any more. It was quickly usurped by "pause," a linguistic device that allowed people in a conversation to construct a rhetorical timeout—enough space for one speaker to call out a person on their queer accident or the other speaker to preempt the queer moment. "Pause" was intended to suspend or stand above all play. I am being tactful in my use of the word *play* here in order to call attention to both the pause-play dynamic and the sexual conno-tation, to suggest that even a pause from real play, whatever that is, shifts us into another kind of play. But now "pause" itself has become outdated; a simple "heeeyyy" is enough to call out—as in "call attention to" or "remove"—queer slippage.

My point here is not to shape black communities as more homophobic than others, and therefore always already backwards, but to illustrate that these homophobic devices are persistent and undying. Many male DPL poets used "no homo" intentionally, needlessly, and jokingly. Our use of the phrase was intended to point out its absurdity: why did we need a term that makes space for male bonding by dismissing any homosexual possibility? We

are a close group who frequently engage with one another humorously, and the "no homo" phenomenon became just another tool in the joke box for us to bond over. During our weekly basketball games, we frequently parodied the queer aspects of sports. We would scream out common basketball calls such as "stick your man," or "play good D," laughing rambunctiously as we added "no homo" to the end of each one, thus parodying not only the queerness in basketball but "no homo" itself. Our homophobic imitation was "characterized by ironic inversion." We flipped "no homo," using it "with critical distance" (Hutcheon 2000, 6). By making fun of it and those who used it to affirm their own heterosexuality, we suggested that the term was beneath us and thereby ironically affirmed our own heterosexual manhood. Moreover, despite our own homophobia, we attempted to disempower "no homo" while continuing our close—read "queer"—relationships with one another.[12]

The inversion, however, was often undermined. Although our use of "no homo" appeared to champion a pro-queer position, we were asserting our homophobia through our straight male privilege, never worrying that the term could mark us as outsiders. This is not to suggest that the term could be used in good ways and bad ways; rather, I am pointing out that our use of "no homo" could be simultaneously inclusive and exclusive. In his introduction to *Sweet Tea*, E. Patrick Johnson (2008) beautifully illustrates the ways in which the experiences of black gay men of the South cannot be reduced to whether or not they were welcomed or unwelcomed. They must be understood in the context of southern hospitality and manners balanced with the homophobia of the Bible Belt. I wonder if there is way we can extend what Johnson calls "a site of contradictions" to account for the ways in which DPL men's desire for inclusivity balances with their heteropatriarchy (1). Rather than calling DPL pro-queer or anti-queer, pro-woman or anti-woman, I want to understand it as a radical space that works toward inclusion while, both knowingly and unknowingly, striving to maintain straight male power. By pointing out how privilege is maintained, we can take the necessary steps toward constructing more inclusive poetry spaces.

My use of the word *queer* follows Eve Kosofsky Sedgwick's (1994) "open mesh of possibilities, gaps, overlaps, dissonances and resonances, lapses and excesses of meaning when the constituent elements of anyone's gender, of anyone's sexuality aren't made (or can't be made) to signify monolithically" (8). In this way, *queer* points to the messy, irregular gender politics of DPL. Nevertheless, I am aware of Johnson's (2005) "quare" critique of queer; as his riff off Judith Butler points out, "*there is some 'race' trouble here with queer theory*" (129). In my racially queer, or "quare," reading of the DPL men, who can be both homophobic and queerly comfortable in their close-knit relationships, I offer an illustration of the Lounge's queer politics as it acts as a filter for multiple masculine/ masculinist manifestations.

In December 2007, I performed my "Not Another Love Poem" at DPL. Opening with the line "This is a love poem," the piece was a response to the slam and spoken word poets who spoke of how tired they were of hearing generic poems about politics, race, and rape. The poem was unified by the idea that all of my writings are love poems because I write about and for those whom I love and about issues that are dear to my heart, including the problem of dismissing other poets' meaningful life experiences as clichés. I am an energetic performer, with a rapid-fire delivery, and the audience cheered loudly during most of the poem. But they quieted during one part of the performance, when, scowling, I said:

I write love poems
That sound like war anthems
Get up stand up anthems
We keep glocks cocked on grimy blocks
Cause we stay ready for revolution anthems
I'ma start shooting if I don't see solutions anthems
And them
Brothas and sistas are starting to understand
That this is a love poem . . .

A cry for black men to love black men
Real revolutionary like
Arms stretched
Chest to chest
Hugs that laugh at black leaders who claim to advance the race
While simultaneously denying black gay men and women their
 rightful place at the table
How dare you
They too are colored
Pigmented with the very histories that tried to steal your
 humanness
Now
You want to continually take away theirs
Go ahead and play white male patriarch if you want
But remember that niggas in white face still got big lips and
 broad noses
You aint fooling nobody
Cosmetic surgery can't erase history

While no one in the audience responded aloud, the homopho-
bia in the Lounge was palpable. Their silence made it clear that
DPL was not ready for the message. They were used to the oppo-
site: a prominent performer freely remarking on stage that he
thinks a particular person is "fruity pebbles"; another screaming,
"I'm not with that gay shit." DPL was an unsafe space for queer
folks. Damnyo, who was once the only openly lesbian DPL family
member, told me during a 2009 interview, "While there are no
real big homophobic instances I can think of, there are a bunch
of small things and they begin to add up to something large."
Damnyo dresses in an urban-male style, and she freely reads erotic
poems about women. But as she explains, "it's different for women.
It's more accepted. I bet there would be problems if a man read a
poem about loving and living for another man." In 2007, there was
still no openly gay male poet who frequented the Lounge, and
the one male who was suspected of being gay was often chastised
and questioned. When I spoke to him, he agreed with Damnyo's

statements. The "small things," as she called them, have been enough to keep many openly gay men and women from acquiring true DPL familial status.

Nevertheless, DPL was making a few small changes. In November 2009, it organized and hosted the national poetry festival Ink Slam and reserved one night for a LGBTQ showcase. It was a token gesture, and the performers that evening were mostly women, but the event was a small step in the right direction. As in the case of DPL's annual women's night, more needs to be done, and I hope the Lounge will come to see the LGBTQ showcase as an oversimplified beginning rather than a fix. More recently, openly queer poets such as Edwin Bodney and Terisa Siagatonu have not only established themselves as DPL family members but have altered us by demanding growth, love, and acceptance. Edwin is a two-time slam national semifinalist. He has appeared on TVOne's *Verses & Flow*, performs at many colleges and universities, is a teaching artist at SayWordLA, and is a regular host at DPL. He holds a degree from the Fashion Institute of Design and Merchandising and reads beautiful poems about being black, being gay, and being black and gay. In my favorite of his poems, "The Night My Father Accompanies Me to a Gay Bar," he writes:

The air is a hot
cast iron griddle
And everyone on the dance floor
Is a vessel of color and steam
Sizzling into
a pallet of sex
And dreaming boys

And my father is with me tonight
A straight, black man
I never thought would say yes to me
who I said I wouldn't write poems about anymore

But ain't that what being a poet is?
Writing about the things we swear we're not gonna write about
 anymore

Edwin's unapologetic joy in performing this piece is enough to
make almost anyone smile. On the night I first heard it, DPL was
packed with bodies and energy. Edwin, beaming, performed as if
he were still in the club that he describes in the poem, and the
audience nearly erupted when he said:

6 months before this night
My father almost killed himself
So he moved out
Admitted himself to some clinic
Where they don't let you visit
But you can drop off dirty laundry
And cigarettes

And I don't even smoke
But I inhaled two to the very end on my way to bring him things
 he asked for

And do you know what it is to question
If whether this time will be the first time
You can save your father with a poisonous thing?

But this
This poem is not about my father dying tonight
This poem is about
The day my father decided to live
Honey!

To be a redemption song for all we never had
Before now
I am too drunk to actually hear
The song that the DJ is playing

But I'm sure it is some Katy-Kesha-Britney mash up with Pitbull
 rapping in the background because this is North Carolina and
 this is all they know
I am also flirting with the boy my father met and set me up with
 while he was in therapy
Because, of course, he thinks we don't have standards
But this one happens to be cute

Now my father ain't ever had no rhythm
But he continues to dance on the 1 and 3 beat anyway
And his smile is the only song I need to hear

I distinctly remember someone yelling back, "*Yaaasss*, honey!" It
was incredibly beautiful to watch my home venue grow big enough
to handle such honest love.

Edwin began coming to DPL as a young spectator in 2004,
but it was not until 2010, during his college years, that he started
regularly attending and establishing himself as a family member.
During a 2015 interview, he told me that volunteering for one of
the DPL's creative endeavors with the hip-hop group the Black
Eyed Peas solidified his membership because it required him to
meet with people outside the scheduled Tuesday nights. He later
said, "The following year, slamming for DPL, . . . I met you and
Shihan, who is really the main figurehead of everything, and once
that happened my involvement in the Lounge became a perma-
nent, heavy, irrevocable thing."

Edwin told me that the sense of awe and excitement he felt
at DPL, coupled with the "overwhelming sensation of intimida-
tion of being new to this space," overshadowed the homophobia. "I
can recall that when I first started coming, you didn't hear anyone
expressing queer culture, or identity, and if it was it was women."
Edwin's "anyone" did not include Damnyo, as she was not regularly
reading at DPL in 2004 when he first began attending. He noted
that when he first started coming to the venue, DPL had two
straight-male hosts and a straight-male DJ, and his remark should
remind us of the importance of including queer folk and women

in prominent positions. While he and I could not mark the particular moment at which DPL began to move to a less sexist and homophobic space, we did agree that the regular queer presence of folks like him and Terisa had sparked critical change.

I love Terisa, whom I call "RiRi," with all of my heart, and my reading of her is colored by that fact. She is a Samoan poet, a three-time national slam champion finalist who tours internationally. Terisa works with Bay Area Youth Speaks, holds a master's in marriage and family therapy from the University of Southern California, and is passionate about social justice. Above all, she is one of the kindest and most generous people I know. She was there for me during an incredibly difficult moment in my life and taught me how to love myself beyond my own failures and mistakes. Terisa and her work are reminders that love is more than a feeling; it is a politics, a choice we make to lead healthier and more connected lives.

During a 2015 interview, Terisa told me that the first poem she performed at DPL was about being a student of color at the University of California, Santa Cruz. She immediately made an impact with her smart, passionate, and relentless work, but "it was Natalie's invitation that made me feel more comfortable, and when I moved to L.A., it was Edwin who reached out to ask if I would try to make the team. And, Shihan later jumped on the thread telling me to be on the team." People reached out to her because they had remembered how incredible a poet she had been. In 2011, when Santa Cruz's college slam team came to DPL for a regional competition, Terisa performed "Trigger," a poem about queer suicide, and "the love I got [from that poem] led me to understand the community DPL was working to foster."

Natalie is an important figure to take into account here, as her demand for a less patriarchal and homophobic venue was critical to the shift. Due to a painful falling out with Shihan, she no longer attends DPL, yet in all of her brilliance she managed to open up DPL even as she was simultaneously closing it off. She made it a safer space for women and queer folk, but only if a poet were in her

chosen circle. As DPL's first woman host, she radically shifted the Lounge, and her transitional presence was necessary for growth.

While both Edwin and Terisa remember Natalie as an important person, they also both mark Shihan's acceptance as the key. While we can read the patriarchy inherent in that scenario—Natalie did the critical work but Shihan is still the gatekeeper—I also want to describe it in its proper context. Shihan is very guarded because, once he thinks someone is deserving, he becomes overly giving. As the only week-in, week-out family member and producer since the Lounge's beginning, he almost always grants his friendship along with DPL family member status. And he takes both very seriously.

Edwin and Terisa are both evidence of DPL's growth. Since they have joined the family, Alyesha Wise, a queer black woman, Jade Phoenix, a self-described male-to-female trans woman of color, and other LGBTQ folks have become family members and regulars. Yet while there has been and continues to be an enormous amount of growth, the gender relations in the Los Angeles slam and spoken word poetry scene attest to the fact that the Strong Black Man still has cultural currency and that, as long as there is an assault on black men, he will always pop up as a means of defense. The rift between DPL and the Leimert Park poets is wrapped in the question of who performs the version of black man poet better and who is more equipped to deal with the kinds of pain black men must endure. Whether the problem lies in the differences between the Lounge and Leimert Park or in maintaining DPL's male ranks at the expense of women or the exclusion of queer men, the region's slam and spoken word poetry community is muddied with problematic race and gender issues. For solvency, we cannot focus solely on men as the solution, as this would only sustain patriarchal logics that lack intersectional nuance and produce yet another method of oppression veiled as activism. DPL and the Leimert Park poets illustrate how new performances of black masculinity must take into full account all the ways in which straight black men have exerted versions of violence as controlling mechanisms in black communities. The troubled race and gender

politics examined in this chapter are just a few examples of the many problems in slam and spoken word poetry communities across the country.[13]

As a young black spoken word poet who holds familial status in DPL, I continue to support women and queer poets who are working to make the Lounge a safer space for women, queers, and even Leimert Park poets. That commitment is a testament to my love for DPL, its family, and its growth. For all the good the Los Angeles slam and spoken word poetry scene has done, we must continue to confront its gender and sexuality issues. We must work toward multiple kinds of black male performances, in which individuals are strong enough to deal with pain and also strong enough to admit that gender is not fixed. Perhaps the goal is not gender reform per se, as that often produces toxic masculinities that reprise forms adhering to normative behaviors and roles. We must push beyond fixing old problems with old tools. In other words, we must not use either-or logics—that is, *strong* or *new*—but creative logics that search for emerging, healthier masculine and male performative possibilities that take into account the fluidity of our "thick(er) intersectionalities" (Yep 2015, 86). They are contingent not only on race, gender, sexuality, class, and history but on space, moments, neoliberalism, lived experiences, and other vectors of difference. By openly and honestly dealing with our "thick(er) intersectionalities," DPL can advance toward becoming the safe space it purports to be.

3

SlamMasters

Toward Creative and Transformative Justice

Sometimes the village just doesn't want every child. And,
sometimes, you gotta stop pretending like it does.
—Terisa Siagatonu, "Meauli"

I first attended Poetry Slam Inc.'s National Poetry Slam in the
summer of 2002 as member of Team Green from Los Angeles.
As a venue, Green was started by Damon Rutledge, but it fea-
tured so many Lounge poets that many saw it as DPL's B team—
that is, as the team you tried out for if you did not make DPL's.
This was certainly true in my case. Nonetheless, my team—which
also featured Shihan, Gina Loring (who placed seventh in the
world that year), Thea Monye, and the renowned actor Omari
Hardwick—was so talented that it nearly made it to the final
stage. In 2003, the team, which included me, Sam Skow, and for-
mer DPL team members Sekou Andrews and Steve Connell,
won the national slam title.

In those early years, I remember sensing an anti–West Coast
bias, for many of the participants on the national scene saw DPL
and its sibling teams, which were mostly comprised of poets of
color, as artificial performers incapable of so-called real poetry. In
fact, in 2003, one of those poets said to me, "I heard Hollywood is

the land of fake tits and fake people. Can you all at least give us real poetry?" In response to such expectations, DPL has rallied around its poets at nationals, and by protesting their mistreatment it has strengthened its own familial community. So if we see our local poets as a family, then how should we understand the national scene, which Marc Smith (2004, 273) has called a "slamily"? At times the national scene feels like extended family, while at other times it feels altogether foreign. Yet despite this family-nonfamily dynamic that DPL and other venues experience, the national slam and spoken word community came together in the summer of 2013 to address the sexual assault of poets by other poets. The situation forced us to consider a number of questions. For instance, what methods can we implement to create effective change? What happens when radical/artistic communities practice social justice methods, especially when those communities are trying to become institutions? And, can an institution remain radical?

Poetic Justice

On August 16, 2013, on an unbelievably humid day, nearly one hundred spoken word poets, poetry slam organizers, and coaches crammed into an air-conditioned meeting room at the Hyatt Regency in Cambridge, Massachusetts, for Poetry Slam Inc.'s annual SlamMaster meeting. As part of PSi's National Poetry Slam, an annual week-long competition featuring more than eighty teams from cities around North America, the SlamMaster meeting functions as a kind of PSi congress in which each participating poetry venue is allowed one vote per issue. The 2013 NPS website had reminded us, "If you're a SlamMaster of record for a poetry slam venue, you should be at this meeting (or you should plan ahead of time to send a proxy). . . . In addition to joining in the lively discussion about the most pressing issues in slam, remember that your venue's future participation in PSi events is based on your attendance at this event. . . . [And] all parties are welcome, although only SlamMaster (or registered proxies) may vote" (National Poetry Slam 2013).

In the nine years I had been going to the National Poetry Slam, I had attended the SlamMaster meeting three times, but this was the first time I was there as a proxy, representing both DPL and Elevated of San Diego. Most of these meetings are unnecessarily long, at least according to Shihan, who has attended more than a dozen of them, but the 2013 session proved to be one of the longest and most emotionally explosive in PSi's comparatively short history. Although it began as a typical discussion of the coming year's business and PSi bylaws, it escalated into drama when Nicole Homer of New Jersey's LoserSlam asked, "How do we get someone banned from PSi events indefinitely?"

Nicole is a poet, a teacher, a slam coach, and the organizer of the LoserSlam, which is the state's longest-running slam poetry competition. She is also a member of the governing body of New York City's Urbana, a nationally known poetry venue once held in the famous Bowery Poetry Club and Café in the East Village. Nicole now holds an MFA in poetry from Rutgers University, Newark, and she facilitates a monthly women's writing group and a weekly writing workshop. She describes herself as a geek without stage fright. While I have known Nicole since 2008, we do not speak very often, though her poems tell me she can be unflinchingly brave. Even more, they suggest that, as a woman of color, she must be bold and, at times, unyielding; and I know she is equipped with a robust understanding of the ways in which the legal system has failed women. Now, at the 2013 PSi meeting, with her youngest daughter in her arms, Nicole raised the subject of the New York–based poet Brian "Omni" Dillon, a white male who had allegedly sexually assaulted two white women in the community, and she fiercely and unapologetically demanded community and organizational accountability.[1]

"The conventional frameworks, constructions, and assumptions of thinking about crime, law, and justice have stood subject to haunting strains of critique" from those who recognize that our current juridical methods are little more than mechanisms of power to sustain a racist, sexist, classist, homophobic, and xenophobic status quo (Williams and Arrigo 2004, 1). Critical

race theorists, feminists, queer theorists, anarchists, peacemakers, social justice workers, and others have all launched important attacks against the U.S. justice system, and in the process they have established new ways of thinking about and through legal policies and practices and provided creative alternatives (Williams and Arrigo 2004). Recognizing their own failures in cases of sexual assault, Joel Epstein and Stacia Langenbahn (1994) produced a report for the National Institute of Justice that called for top-down changes in how our criminal justice system deals with sexual assault. The report called for widespread organizational changes in defining rape, offering sensitivity training, employing victim advocates, and sponsoring outreach programs with multilingual services to better serve minorities and immigrants, who do not use rape crisis centers as frequently as white women do. Additionally, they called for sweeping procedural changes and increased community engagement. They did not suggest that prosecuting sexual predators is the only or most effective mode of justice, but they did demonstrate that our systems and methods are appalling, offensive, and life-threatening. Basing its claims on data from the U.S. Department of Justice and the Federal Bureau of Investigation, the Rape, Abuse, and Incest National Network (n.d.), the largest anti–sexual assault organization in the nation, asserts that "only about 2% of rapists will ever serve a day in prison." While we may question the network's statistical methods, it has become increasingly evident that our justice system woefully mismanages sexual assault cases on nearly all fronts.

When the current system fails or is unwilling to address particular needs and realities, stakeholders sometimes turn to alternative methods such as restorative justice or holistic law. Yet as Esteban Lance Kelly (2010) poignantly asks, "in the process of restoration, *what is it that we are restoring?*" Writing about two Philadelphia groups, Philly's Pissed and Philly Stands Up, which "emerged in response to a series of sexual assaults that consumed the anarcho-punk community during a summertime festival in Philadelphia in 2004," he details their successes and failures after they organized around the work of eliminating sexual assault and

rape culture. Offering the anarcho-punk community as a kind of theoretical and practical test case, he reminds us that alternative communities do not always transgress but often promote patriarchy, sexism, and other systems of oppression. Restorative justice methods have their limitations. As Kelly notes, "people [are] never the same after sexual assault," and "sexual assault is a catastrophe that rips through an entire community." His study of the "transformative justice framework [in West Philadelphia] . . . acknowledges the broader systems of oppression (e.g., racism, male supremacy, capitalism, and the prison-industrial complex)," which operate as networks "that instigate sexual assault." In this way, I want to use what Kelly calls the *transformative* impact" to think through the national slam community's desire for justice (49).

As regards to the controversy at the 2013 SlamMaster meeting, I have chosen to focus here not on what constitutes rape but on how communities form and reform around difficult issues. Additionally, this chapter is not about figuring out who is and is not a sexual predator, nor is it about the facts concerning the alleged assaults. Instead, it asks, What happens when a community puts alternative justice methods into practice? I spoke to numerous people who were involved in the situation, but many wished to remain anonymous, and I felt that including their interviews and discussions would make them easily identifiable. Among poets who were willing to share their words publicly, some were comfortable about revealing their names, while others preferred to use aliases. I found it difficult to construct a complete story with so many missing parts, but the process was also a reminder that ethnography is anything but a complete story, always an imperfect narrative, rife with complexities that reveal as much about the ethnographer as they do about the community itself.

The Meeting That Changed It All

Akeemjamal Rollins, a poet who describes himself as "black, male, gay, tall," traveled from Cleveland to attend the 2013 SlamMaster

meeting. In an interview later that year, he told me that Nicole's question had been planned and organized by a group of poets who were fed up with PSi's seemingly laissez-faire attitude toward sexual assault. "I don't feel like everyone knows this," he said, but "it was actually planned by some of us to go in and bring that to attention and support one another." He described sitting in on this important women-led organizational meeting around safe space and slam: "Nicole was kind of the spearhead on that day, . . . and I just sat in on the conversation because it's something that I feel strongly about and that I have my own views on." The well-known poet Rachel McKibbens agreed with Akeemjamal's assertion. She told me during a 2013 interview, "Of course Nicole Homer's question was planned."

> There are numerous collectives who say, "No more." Here's the thing: After Trayvon Martin was murdered, and after his murderer was let off like scot-free, I remember Obama saying something like we needed to calm down, settle down. We are a nation of laws. We have to move on. And I thought, yeah, we are a nation of laws. We are not a nation of justice. And what's happening now is that people understand, if you're gonna get street, gonna start harming muthafuckas. . . . I'm not saying there's a van of people about to jump somebody. I'm saying we recognize, say Poetry Slam, Inc., say Youth Speaks, all of these organizations who are so scared to make a move to somehow decrease the levels of assault going on and harassment. They're so scared to do anything, they're doing nothing. And after nationals and after there was a particular perpetrator in our scene who was allowed to be on finals stage. And, there's nothing that could be done with that. I mean, he earned a spot on final[s] stage, fine. And what's gonna happen is the streets gonna come for you. And if it's through hissing and booing while you're on stage. . . .

I have known Rachel for fifteen years now. She is an accomplished and mesmerizing poet whose work has a subtle but vicious bite. Rachel is a Mexican woman (who sometimes reads as

white-appearing) and, with a museum of tattoos on both arms and hands, she is a powerful and important matriarchal figure in the national slam community. While most people know her as a New Yorker, she is actually from Santa Ana, California, and she told me she has been writing since she first "learned how to . . . put words together." Rachel fell in love early with the "misogynistic stuff" of the poet Charles Bukowski and sees herself as a "smaller performer [who] really leans on quietness . . . because the more quiet kind of understated stuff where the monsters aren't as obvious, . . . that quietness that you have to be a lot more afraid of."

One of my earliest memories of Rachel is standing next to her at DPL, which felt like home to her then, as she handed me her baby son Holden before stepping on stage to read a poem. Holden is the subject of her best-known piece, "Mother's Day, Central Park"; and as he has grown older, he has learned all too well how strong and fierce the women in spoken word communities can be. In the poem Rachel writes:

My son comes to me, holding

thirteen severed tulip heads.
A present he's made, just for me.

I knock the flowers from his hands,
grab him by the arm, move quickly
from the crime scene.

I explain: the lake, the trees, flowers, birds—
do not belong to us.

I watched something bright and alive
go pale. His head lowers like those stems,
their broken necks.
Chin against his knees, he stares
into the grass. Does not speak again.

A mama forgets what her weapons can do.
Can't know which of her failures
will be what does it.

What Holden learned early, we learned as well during the 2013 SlamMaster meeting. Nicole's question sparked vital yet sometimes problematic conversations in slam and spoken word poetry communities throughout the country. It was a necessary and gut-punching move that, for a moment, made the large air-conditioned room feel small and suffocating. Taken by surprise, Henry Sampson, PSi's then president, stumbled and falsely answered, "No." In fact, PSi has indeed banned poets indefinitely from the National Poetry Slam. In 2005, Shihan, Queen Sheba of Atlanta, and I had been banned for protesting what we felt was unfair treatment during the national competition, held that year in Albuquerque. The home team, Albuquerque's ABQSlams, had been crowned as champion, with Slam Charlotte placing second and Fort Worth Poetry Slam and DPL tying for third. Soon thereafter, in front of a stunned crowd in the city's sold-out convention center, Queen Sheba, who had competed for Slam Charlotte that year, grabbed the microphone and voiced her displeasure: "Albuquerque, I love this city, and I love y'all. Y'all have shown us so much love throughout the week. But the booing and disrespect that we received tonight is uncalled for, and I know y'all have better home training than that." In support, Shihan and I stood beside her with our arms fixed as upraised Xs.

While all of our suspensions were eventually lifted, Sampson's knee-jerk "No" was particularly appalling because it positioned PSi as an organization that was willing to punish particular poets for speaking out but not for sexual assault. PSi seemed to care more about its product, which is a well-run show that often champions the rights and safety of minoritized people, more than the actual safety of the poets who produced the product. It was positioning itself as an organization that supports and promotes outspoken artists—as long as it can dictate when and for how long the poets speak out.

During our interview, Rachel told me that she had been "loud and confrontational" about sexual assaults at the National Poetry Slam in 2002.

> And to be honest, the next time I saw any actual activism came from Da Poetry Lounge in 2000, what, 5, in Albuquerque? I've always thought about that. And just knowing that this . . . group of poets who were primarily black poets were banned immediately, and were chastised on forums and ridiculed for standing up for themselves . . . , that's always kind of sat in the back of my mind when I think of anyone else throughout the scene who has wanted to call out something and has either chosen not to or has done it in a way that is a lot more passive-aggressive, . . . not as directly confrontational.

One can see our indefinite bans, along with our harsh public and private shaming, "as complex social function[s]" wrapped in "a certain 'political economy' of the body" (Foucault 1997, 25). PSi seized our public act of resistance in an attempt to correct our defiant bodies and make them "docile" (136). This "'political anatomy,' which was also a 'mechanics of power,'" reminded the national slam and spoken word body that speaking back to institutions was welcomed but only within PSi's defined structures and only when the institution being critiqued was not PSi itself (138).

Yet our punishment cannot be understood solely in terms of repression, coercion, and correction but must take into account the positive possibilities it opened in our communities, whether through Rachel's memory of the moment as a locus of racial injustice in the national slam and spoken word community or through the voices at the 2013 SlamMaster meeting who called Sampson's attention to our punishment. The fact that no one had asked for our testimony until after the penalty was set openly illustrated PSi's undemocratic practices and unequal treatment. For a number of poets, including many who had initially chastised and ridiculed us, the incident planted a seed of distrust in PSi. It was no longer

the radical and safe community we had assumed it to be. As Boris "Bluz" Rogers, a poet from Charlotte, North Carolina, told me, "at this point [the National Poetry Slam] is just a game, and the novelty of family has kind of worn off. There are only a few people that I deal with, and I deal with them outside of Nationals. And Nationals is just becoming a place where I go and try to just show that I can win. . . . That's it."

Bluz is a two-time National Poetry Slam champion and was a 2012 finals' stage host. He has worked for CBS radio, Radio Disney, ESPN, SPEED TV, BET, and NASCAR, and won regional Emmys for his work on *NASCAR: Today*. He is a tall, dark-skinned black man with long dreadlocks who writes with a charming southern sensibility, and it is difficult to not feel warm and welcomed when he performs pieces about his daughters. So after speaking about his family during our 2013 interview, we were able to seamlessly shift into a discussion about the SlamMaster participants' responses to Nicole's question. Bluz recalled the emotionally dense conversation as a "slippery slope of scenarios," in which "every slam poet [was] overly opinionated."

> It was a lot to deal with for everyone. . . . I know there were some people who were saying that they have lawyers that you can talk to and you can ban a poet from nationals but you can't ban a poet from a city. Which made sense. . . . If you can't ban them from a city, then, you know, how does that work in terms of their rights? And now we're infringing on someone's rights to go wherever they wanna go regardless of what they've done. And then it turned into, well, what if they're being falsely accused? And I don't know the brotha's name, he was a brotha and he kinda said, well, not even kinda, he said there's been times when he's been pulled over or you know stopped by the police and he had done nothing wrong and that accusation was enough to, you know, put a fear in him. And he asked, what does that scenario look like? And, and, I wish I could really quote him because whatever he said sparked a fire.

Bluz was speaking of Sherod Smallman of Philadelphia, but he was also suggesting how easily his own southern charm, his love for NASCAR, his appreciation of poetry, and his work in the national slam community are, in many people's minds, subsumed by their assumptions about his blackness. He told me, "We're black, we're men, and we're angry. That's how a lot of . . . I guess the majority of some of the slam world kinda sees us."

During the SlamMaster session, Nicole and a few others shared emotional and poignant testimony about the need for PSi to act swiftly and fiercely in the name of justice for the victims and survivors. Meanwhile, the object of their anger, Omni Dillon, sat in the room about five feet away from them. His head was lowered, he was wearing dark sunglasses, and his long black hair covered much of his face. He and the rest of us listened to point after point, none of which included the names of the alleged or alleging parties, ranging from demands for an indefinite ban, to accusations of PSi's willful incompetence, to the potential harm of allowing Omni to remain a member, to the need to mention sexual assault in the bylaws. The room was filled with emotional tension, which erupted when Adriana E. Ramirez, a poet from Pittsburgh who is both a survivor of sexual assault and a mutual friend of Omni and one of his alleged victims, suggested that stakeholders should focus on creating well-thought-out policies before taking direct action against Omni. Many of the people present already disliked Adriana, not only because of her friendship with Omni (which she has called a "powder keg of awful") but also because of some other off-the-record incidents. They began booing and yelling at her and calling her a supporter of rape. At this juncture, Sherod Smallman and Christopher Michael of Killeen, Texas, both asserted that we should talk to lawyers and the authorities in order to properly get to the bottom of the alleged assaults and not open ourselves to defamation lawsuits. The men, both black, agreed that we should remain vigilant in making our slam and spoken word communities safer but should do so in a way that is backed by state and federal law and PSi's bylaws, which, they said, should be amended.

Christopher has made it to the National Poetry Slam finals multiple times and is the slam master of the Austin Poetry Slam. He is also a nurse who has worked with sexual assault victims and survivors and has been, he says, a survivor of molestation as well as falsely accused of sexual assault himself.[2] During a 2013 interview, he recalled the moment at which the SlamMaster meeting boiled over:

[The discussion] went back and forth for a while and eventually somebody said we actually do have a process. And then it went into a discussion of safe space. I made the comment, "We can't just ban somebody from National Poetry Slam. They could still come to the host hotel. You can't ban them from a public event that people are paying for. You just can't accuse some dude of rape and then take some action against them. They have to be convicted. There has to be some evidence. PSi has to hire a lawyer to tell us what we can and cannot do. And then a lawyer needs to address situations like this. We can't just be randomly banning people because then we open ourselves up to lawsuits and harass-ments." The big problem was somebody said, "Raise your hands if you've ever been sexually assaulted," or something like that and a few women raised their hands. And I said, "You know what, how many men in here have been falsely, truly falsely accused of sexual harassment?" And man, there was uproar, like, "How dare you?" As if I was trying to compare. My point is there's a lot of heinous stuff being done by men to women. But there are also women who take advantage of stuff like that. And there are some men out there who have had their lives ruined from a lie.

Christopher's question about false accusation is problematic because it pits women directly against men and treats justice as a zero-sum game. Additionally, it ignores the glut of research that illustrates how few accusations turn out to be false. Yet like many black men, Christopher has a strong and historically grounded fear of the justice system and is even more afraid of systemless justice, and his question highlights his reasonable concern about being

harassed, charged, and convicted by virtue of accusation alone. This fear was made all the more evident when Sherod, after being called a rape supporter, stood up at the front of the room and shouted out his defense into a meeting that was now filled with people who were yelling, crying, hugging, and storming in and out of the room. Weeping, he said:

We have to be very careful about the line we are crossing here. We don't want to not be fair. We don't want to be unjust. We don't want to breed our own form of justice in this situation. We have to have some balance. Some objective balance. Now I don't know what happened, nobody really does but the people involved. But we gotta get lawyers involved. We have to protect the organization. We have to protect the people involved. And what we don't want to do is put our own . . . brand of justice on people. We gotta get lawyers involved. What does this look like in the long run? We don't want to falsely accuse or crucify people in our . . . own social jury because that's what we're doing. It becomes a kangaroo trial. They said, "Pick sides. You gotta pick a side." I'm not picking a side. I don't even know these people that good. I'm associated with them. And I've known them for years and of course have no beef with these people. But I don't know what happened. We don't know. We don't know. Why don't you look for justice in a court because this is not a court? If this person has done it, then he needs to be prosecuted to the fullest extent of the law. And you know people have been falsely accused in the past, especially African Americans. And I'm an African American male that's been falsely accused of numerous things. I was eighteen years old just walking down the street. It was in Philadelphia. Basically what happened was I was walking down the street from my job, I think I wanted to make a stop somewhere, and then this guy just ran by me and I didn't think anything of it and the next thing you know cops are all over me. I mean literally all over me. It's cop cars; it had to be two or three. And these two cops put me in cuffs. Didn't say anything, wasn't read any rights, had absolutely no idea what was going on. I was

cuffed and it was just like, ya'll don't know me. Where did this come from? And they had nothing on me. And then when they find out they were like "Oh, you know how it is." And I was like, no. You just cuffed me and patted me down. That's a big violation. There have been numerous things. I mean, I've been pulled over for driving too slow. This one cop tried to pat me down, I mean, like literally he tried to dig in my pocket. And I was like "Whoa whoa whoa whoa whoa, you're not gonna touch me. You're not gonna dig in my pockets. I gave you my registration, you're not gonna touch me." And it didn't matter if I was right or wrong. All those cops saw was a suspect.

Sherod's narrative forces us to ask, What happens when the safety of one group in a community seems to be in direct conflict with the safety of another group in that community? What happens when one group wants or needs an entire community to act swiftly on an accusation when another group declares that accusation is not enough reason for action? In other words, what happens when different safe spaces collide? In *Mapping Gay L.A.: The Intersection of Place and Politics*, Moira Kenny (2001) writes that the idea of safe space was "developed in the context of the women's movement" and "implies a certain license to speak and act freely, form collective strength, and generate strategies for resistance, . . . a momentary respite from oppression, . . . a means rather than an end and not only a physical space but also a space created by the coming together of women searching for community" (24). Yet even though it is necessary, safe space as a concept has been heavily scrutinized. Conor Friedersdorf (2015) suggests that student activists have "weaponized the concept of 'safe spaces,'" a position that those with power and privilege take in order to silence of-disenfranchised subjects. On the other hand, J. Jack Halberstam (2014), as he works to ensure we remember the history and political potential of coalition building, claims that "as people 'call each other out' to a chorus of finger snapping, we seem to be rapidly losing all sense of perspective and instead of building alliances, we are dismantling hard fought for coalitions." Clearly, safe space has

proven to be a fraught concept, if for no other reason than that there is no universally agreed-upon definition of safety. According to Christina B. Hanhardt (2013), the creation of safe space has hinged on public policies that see policing and privatization as effective measures for dealing with urban violence, which have had noticeably disastrous consequences for poor and of-color neighborhoods and people. LGBTQ communities have eschewed their ties to anti-racism and anti-poverty movements in favor of state-recognized legitimacy and safety. "This is not to suggest that gay identity per se is complicit with urban-centered capital accumulation and criminalization," writes Hanhardt, "but . . . political goals that call for these forms of state protection must be understood at least in part as expressions of the [racialized and classed] risk management that is central to those processes" (32). Perhaps that is what occurred in the SlamMaster meeting, where almost all of the black men who spoke argued in favor of the court system or more structured methods. Given our country's well-documented racist legal practices, the black male poets in that room called for law and order because they feared a systemless justice system more than they feared the current one. Indeed, Sherod's last sentence, "all those cops saw was a suspect," is particularly telling in that it reflects his fear of always being on trial, of always being seen as guilty.

Sherod, like most of the black men in that meeting, was yelled at, chastised, and silenced, but not because he presented any immediate threat to Nicole.[3] She was in the back of the room and he was in the front, and he never showed signs of doing anything more than raising his voice. Even if he had, no one else in the room would have allowed him to escalate, and I am certain Sherod himself would not have allowed anything more. Rather, he was yelled at because his black male body was a threat, as it always is, by virtue of being loud, excessive, unruly, illegible, pathological, and outside the confines of white liberal, neoliberal, and conservative structures. As I have written elsewhere, gay safe spaces (Hanhardt 2013), prison systems (Alexander 2012; Blackmon 2008), HIV/AIDS research (Cohen 1999; McCune 2014), and nearly everything else

in this country were built on the logic that black bodies are inherently unsafe and must be reeled in, that the world must be protected from them (Johnson 2015, 179).

But black women also fear the violence of the justice system, and many also fear black men for perpetuating abuse and not standing with them in their fight for safety and liberation. In *Catching Hell in the City of Angels*, João Helion Costa Vargas (2006) shows that black women are not only vulnerable to the whims of the state (as black men are) but also susceptible to state violence (in ways many black men are not). Kimberle Crenshaw (1989) coined the term *intersectionality* to indicate how black women are "multiply burdened" and often erased in feminist and antiracist discourses as well as to show how "the entire framework that has been used as a basis for translating 'women's experience' or 'the Black experience' into concrete policy demands must be rethought and recast" (140). The poet Porsha Olayiwola, who is the 2014 individual World Slam champion, the 2015 National Slam champion, a co-founder of Boston's House Slam, and an "overall fly dyke-god," captures this in her poem "Rekia Boyd":

> Last night, no one showed up to march for Rekia Boyd.
> Rekia was shot dead in the head by cops in Chicago on Monday.
> A Cook County judge acquitted police of killing Rekia
> Dante Servin, charged of manslaughter, went jailbird free.
> Rekia Boyd was a 22-year-old unarmed black woman living on
> the south side of Chicago,
> and last night, no one showed up to march at her rally.
> I guess all the protesters got tied up.
> I guess all the black folks were busy making signs saying, "Stop
> killing our black boys."
> I guess no one hears the howling of black girl ghost in the
> nighttime.
> We stay unheard. Blotted out. Buried. Dead.
> Black girls receive tombstones too soon, and never any flowers to
> dress the grave,
> so we fight alone.

They will tell you the woes of a black man who got beat by police
 in the street
Beat by the man at work
Beat by the system at the institution
But never of a black woman he took his frustration out on
Never of the black girl he stretched into a casket
They will tell you of the brown boys who get pushed from school
 through pipeline to prison,
but never of the girls who feel the sales
Never of the orange jumpsuits they camouflage into
200 black girls go missing in Nigeria and America puts out a
 hashtag instead of a search party
No one ever causes a riot

Porsha's poem poignantly highlights how black women are also victims of state violence, how they face gender violence, how they are often unsupported, and how erasure is a form of violence. The black women at the National Poetry Slam who organized and called for justice were fully aware of how the U.S. justice system was consistently failing them, and their drive to speak out not only reflected the complexities they were facing but also their fierce desire for a better world. Moreover, as the meeting shifted into arguments about safety that pitted black men against white women, it illustrated the erasures of black women that both Crenshaw and Porsha brilliantly describe, an expunging that does not allow for true liberation.

By shutting down and denying the black male voices in the room, and by disavowing black women's intersectional experiences, the SlamMaster meeting illustrated that black livability is threatened even in the most liberal and democratic of spaces. More, it pointed to how the slam and spoken word poetry communities seem to function safely only when blackness is in check. How else could a question about banning a white male poet who is accused of sexually assaulting white women turn into a discussion about the safe space that black male bodies threaten? And where do black bodies go when we are threatened at nearly every

turn? Where do we go when safe space is built on the logic that blackness equals danger?

Queerlateral Damage

Still buzzing from the explosive SlamMaster meeting, poets and patrons filled Boston's Berklee Performance Center later that day for the final competition of the 2013 National Poetry Slam. The normal excitement of watching the top four teams battle for the national title was compounded by the energy of a group of unwavering women who demanded justice, and, perhaps even more, a safer community. Omni Dillon's team, the Intangibles Slam of New York City, was not one of the four finalists, but it had earned the right to participate in the final stage's pre-competition showcase because it had received a group poem award earlier that week. As soon as Omni walked on stage, many audience members began hissing. They audibly protested whenever he spoke, and eventually their booing and screaming spilled into the entire team's performance.

Given that the Intangibles poetry squad included four young people of color, three of them queer, many people present at the competition had conflicted feelings about the protest. During an interview soon after the incident, I asked a young white woman whom I will call Beth about how the protest might have harmed young queer poets of color who were new to our community. She quickly replied, "It's called collateral damage." A black male poet (who asked to remain nameless) told me shortly before the finals, "I want to work for a safe community too. I really do. But this is not the way to do it. This shit does not feel safe for me. It feels like a witch hunt. I'm scared to say anything except 'I completely agree.'" Certainly, his comment reflects the ways in which male angst mourns the loss of power, but it also points to the need for nuanced dialogue about safer communities.

Sam Cook, a white male poet based in Minneapolis, called the 2013 SlamMaster situation "the most horrifying meeting [he's] ever been in." In a 2015 interview, he told me had been very close to

Omni until he "did the work" of listening to painful but necessary stories about the alleged sexual assaults. Nonetheless, he said, "the organization never should have put Brian on that stage." Sam and I discussed his shame about initially defending his now-former friend, Omni and how PSi might move forward as an organization, and he said that he believes that the matter should have been handled internally before it was made public on stage. "I think that booing the young people on that stage was horrific, but I also think that the organization of mostly women that did that didn't feel like they had an option."

Collateral damage is a military term, and using it as a descriptor figuratively transforms our performance poetry community into a war zone. It also reminds us that, even before the 2013 incident, certain bodies, lives, and livelihoods in our space had been in jeopardy. The notion is particularly troubling because the collaterally damaged are almost always the most vulnerable. In this case, they were young, mostly queer, poets of color such as Simone Davis, a black queer woman who came to the slam community in search of a space in which she could speak and belong. Simone was a member of Intangibles, and in 2014 she spoke to me about being booed and "flipped off" by women whom she had once admired. "The whole week we were dealing with people hating. . . . But when you find out how far this went up the chain of poetry veterans, when you realize that, you feel real small. You feel small, you feel like your voice doesn't matter, your time. . . . Why compete to the highest levels of a competition, just to get shitted on by your peers in a dark room where you can't see who they are but they're calling you out? I don't know."

Simone had never attended the National Poetry Slam before, and she had been excited about seeing the people she looked up to. But the booing really hurt, and she and another of her teammates have decided never to attend again. She explained, "The reason why it hurt a lot is because [of] the nature of the poem we wrote. . . . We took a chance by doing something we felt was semi-original. . . . We took parts of each other's story and threw it in." Simone told me she no longer speaks to Omni and that she decided to "push

everyone away" because the "disrespect that happened on stage" came mostly, in her view, from "the New York community." I asked her if she had known about Omni and the accusations before she went to Boston, and she replied, "There were only two poets in the New York scene that said anything to me about the details of the situation, which they didn't even want to go into, . . . like they were kinda tiptoeing around it. . . . I didn't know how deep the rabbit hole went. . . . They didn't give us a choice as rookies. . . . At no point did they try to bring me in the fold as a rookie in the community, as a woman or as a queer poet, y'know?"

Another poet I interviewed, whom I will call Joe, corroborated Simone's narrative. He, too, was unaware of the particulars and of "how deep the rabbit hole went." He said, "The established poets [who were opposed to Omni's presence] ignored us. . . . There wasn't any kind of dialogue, . . . and that, [for] a person of color, is automatically triggering. I'm not gonna give a shit about you . . . if I have a whole bunch of white folk who think I'm guilty by association." By highlighting the racial component, Joe also emphasized all of the ways in which triggers can conflict and compete with one another. He told me that, after hearing the evidence, he now believes that Omni was guilty of sexual assault. Yet his own need to be heard in that onstage moment, before he was aware of the details, put his desire for a safe space directly into conflict with the desires of others.

After the incident at the National Poetry Slam, Simone was "conveniently dismissed" from another slam group, one led by women of color. Her reaction was, she told me, "I guess I can't be in your group anymore, I guess I'm not woman enough." It was heartbreaking to hear Simone say those words, yet she spoke them without flinching, as if she had said them many times for many other people. Likewise, it was difficult to hear Joe discuss his feelings of being triggered and his sense that a group of white people had silenced him and were treating him as guilty by association. Yet it was equally troubling to know that a group of women, and a few male allies, had been asking PSi to address the issue of sexual assault for a decade without seeing any legitimate results. What

other options did they have? To whom could they turn? Public rage and shame are not always effective, and in some cases they are problematic, but they were all those women had. They, like many rational human beings, had created mechanisms of justice that were vigilant and vicious because the alternatives were frightening and unbearable.

We Are Family?

In *The Complete Idiot's Guide to Slam Poetry*, Marc Smith and Joe Kraynak (2004) write, "Poetry slam reaches far beyond the front and back cover of this book, beyond the walls of your local slam venue, beyond the city limits, over the state line, and across the oceans to international community. Yet the slam community remains as close as family" (274). They proceed to talk ad nauseam about PSi and non-PSi events but limit any further focus on the slamily to a single paragraph. "The slam family," they write, "includes everybody,... anyone who has an interest in performance poetry." Clearly, one should question the assertion that a family can include "everybody." Moreover, their subsequent claim that "all PSi members share an equal status, one vote apiece, nobody better than the next," is not only blatantly false but, even worse, reflects a version of white liberalism that pretends to operate as if we are all equal but does not do the work needed to get there (281).

Most people imagine slam and spoken word poetry communities as heterogeneous spaces marked by radicalism, harmony, and what Jill Dolan (2005, 5) calls "utopian performatives." HBO's *Def Poetry Jam*, the film *Love Jones*, and other pop sources have falsely made these communities seem diverse, even primarily black, "counterpublics" (Fraser 1990, 61). Of course, poetry slams do have "small but profound moments in which performance calls the attention of the audience in a way that lifts everyone slightly above the present, into a hopeful feeling of [utopian possibility]" (Dolan 2005, 5). But those moments are marked and marred by racism, sexism, homophobia, classism, and a host of other troubling community practices.

Although each local scene and venue has its own set of politics and practices that range from extremely conservative to radically progressive, the national slam and spoken word poetry community is diverse in terms of race, class, gender, and sexuality. Nonetheless, white people have historically governed PSi and the National Poetry Slam; PSi's current executive director, Suzi Q. Smith, is the first person of color to serve in that position. The national community rarely questions the behaviors of successful white male poets but frequently derides those of successful poets of color, especially black ones, pointing out the "angry black man yelling about racism and calling it poetry," the white woman "always doing rape poems," and the "angry black woman just yelling." On some level, such racist and sexist comments allow fragile and threatened white males to explain their lack of success and hold on to their place at the head of the slam family table; and this slam-as-family metaphor remains prevalent in both the national and local communities. By borrowing the term *slamily*, sharing poems that celebrate the community as family, or referring to fellow poets as brothers and sisters or mothers and fathers, many participants use the scene as a way to create alternative families "to fit their own realities" (Bailey 2013, 91).

In his fascinating study of Detroit's ballroom culture, Marlon Bailey (2013) reveals the ways in which black LGBTQ folks use performance to create and celebrate alternative gender and sexual possibilities, family, and community, often during moments of crisis. "Family," he explains, "is about and based on the kin labor that members choose to undertake" (95). He argues that in many ways the black family has been a historical refuge against racism and white supremacy. Thus, when black LGBTQ folks are ostracized and excluded from the family because of their sexual or gender identities, they seek refuge in other, self-forged families. Bailey's work is important because it illustrates how "kin labor," or the work of doing family, not only establishes new and alternative families but also exposes and makes up for the failures of our biological ones. Although not always black or LGTBQ, members of the slam and spoken word communities also desire to imagine those

communities as families, and their longing is born from a similar logic. They are looking for people who will better understand their "particular brand of weird," as the poet Donny Jackson told me in 2014. They want to be surrounded by those who will support their performative choices and to be members of a group that aspires to be open and democratic.

In many ways, these newfound families can be receptive, transformative, and inspirational. In 2008, Emmanuel "Def Sound" Rickets told me, "Here is a community where they actually listen to a black person speak. Not automatically write us off as crazy or angry, but they listen. And that's so necessary because where else does that happen?" Def is a poet, a rapper, a DJ, and a stylist who greets his friends with a huge smile, a handshake, and a "What's up, my G?" His comment about acceptance highlights why so many flock to these spaces: they seem to offer both democratic soapboxes and a crowd of supportive people. Yet even though I largely agree with Def, I also know that poets who come to these communities are often reminded of all the ways in which alternative families may appropriate traditional family structures and modes and thereby re-create versions of the failures they were trying to escape.

In a 2013 interview, Bluz Rogers called poetry slams "just a game," a reaction born out of his distrust of PSi as both an organization and an alternative family. He is not alone in that skepticism. Competitive teams that feature poets of color—such as those from DPL, New York's Nuyorican, and Charlotte—have always questioned the slamily. When we listen to members of the larger national community work dogmatically to explain why our teams have won multiple national titles and why we consistently make the final stage, we hear their rhetoric as an orchestrated rescue of whiteness in which the notion of "black as best" is treated as an illogical construction that must be torn down. Bluz told me, "No one questioned how the mostly white team of St. Paul/Minneapolis won back-to-back titles; that was just 'good poetry.' But when DPL and Charlotte did it, the forums lit up about how slam is not about poetry. Whatever that means."

Perhaps what it means is that the national community is willing to allow black people to be part of the family but solely on their white liberal and neoliberal terms.

The spoken word poet Carlos Andrés Gomez calls Marc Smith the "Christopher Columbus of poetry" and has declared that the self-proclaimed slam papi is an artistic and cultural thief. He notes that Smith acknowledges that there have been poetic competitions throughout history, including the "poetic boxing matches" that took place in South Side Chicago two years before the birth of his slam. "Where is this guy's humility?" he asks. I first met Carlos in 2003 when he and I competed against each other at slam nationals, and we later spoke together about the national community, how it imagines black and brown poets, how we could create change, and our issues with Marc. Our chief concern was the incessant reminder, built into PSi's official spiel, that Smith had ostensibly created it all. As I have noted earlier in this book, at the beginning of every bout in any PSi event, the host reads, "The poetry slam was invented by a Chicago construction worker, Marc Smith," to which the crowd yells, "So what?" At Smith's venue in Chicago, the papi himself continues, "That's it, folks. I created it all." This verbal memorial ignores the fact that Marc was influenced by black poets on the South Side and overlooks the talent and hard work of early black slam poets such as Patricia Smith and Reggie Gibson. It is a reminder of the kind of well-meaning, racist, white liberalism that conquers in its attempt to help. This straight white male father, who somehow gave birth to slam all by himself, also re-imagined an alternative slam family that is, in many cases, as toxic as the nuclear family sounds.[4]

The cultural practices within the poetry slam become a way for many people to meet the needs that are not being met in their own biological families, issues that often involve blackness, queerness, nerdiness, gender performance, sexual identity, sexual practice, or any combination thereof. For such people, the seemingly democratic and radical attributes of slam communities make them feel like safe spaces for openly and honestly engaging with and speaking to one's own particular brand of weird. But perhaps we need to move away from family as a metaphor for safe spaces as it is

too limiting and rests on patriarchal assumptions. If we are to find safety, we need to imagine more radical configurations of family and community. Slam reminds us that we must keep searching beyond alternative families to alternative family structures and altogether different possibilities in order to actually discover its transformative possibilities.

The Curious Case of Leo Bryant

Shortly after the 2013 National Poetry Slam, Leo Bryant, a Bay Area poet, publicly accused Jasmine Wilkerson Sufi, also from the Bay Area, of sexual assault. Leo alleges that Jasmine, then his girlfriend, had sex with him while he was unconscious and therefore unable to consent. Both Leo and Jasmine had made their names as a part of Berkeley's weekly poetry slam. In his poem "Superpowers," Bryant (2014) revisits the allegations:

> I wish consent was more to some people than just being a body
> in a bed.
> I wish I could tell you I said, "Yes,"
> that I spoke in my sleep.
> I wish I could tell you that I must've wanted it.
> After all, I'm a man, and men can't be raped.
> I wish that my sex didn't come wrapped in caution tape.
> I wish I could tell you that she didn't fuck me crime scene,
> chalk outline ugly.
> That she was an invited guest of the castle.
> That she didn't lower the drawbridge and raise the flag herself.

Jasmine is a small Persian woman who is somewhat white-appearing, and she has a powerful hug. Leo is a tall, heavyset, black man with an Afro that refuses to be tamed by the bandanas he frequently wears. He has refused to talk with me, perhaps because I still frequent the Berkeley Poetry Slam that he now publicly admonishes. Jasmine, however, has been incredibly candid. In a 2015 interview, she admitted that the pair had been "in a very

unhealthy relationship" and confirmed that the contact in question had happened. She told me, "I don't doubt that he was in some way injured by the incident, and that he's hurt, but I frequently checked in and asked for consent during that night. I asked about four times and he consented each time I asked." While I am neither absolving nor faulting Jasmine, her statement is a reminder that consent is not a one-time thing but an ongoing process.

"What is at issue here is the centrality of sex and gender to the complexity of internalized oppression" (Mercer 1994, 146). From his public Facebook posts to his poems, Leo is working to convince the slam and spoken word poetry community to publicly shame and disavow Jasmine as it has shamed the white man Omni and the black men Roger Bonair-Agard and John "Survivor" Blake. Yet most of the national community has written off Leo as a victim. Early on, the Berkeley Poetry Slam, which publicly supports Jasmine, reached out to him and, according to its public Facebook posts, has now taken legal action toward a resolution. This is not enough for Leo; he wants Jasmine gone. And who can blame him, given that the national slam community has been vigilant in supporting and not questioning victims, especially when predators look more like him and victims look more like her?

At the end of "Superpowers," Leo, barely holding himself together, wishes "that when a boy fell in a bedroom he made a sound loud enough for someone to listen to." If, for Mercer (1994), "rape symbolize[s] a violent act of 'appropriating' the white man's 'property,'" then it is clear why so few have been willing to listen to the fallen *black* boy who, by virtue of his body, is already guilty of using white male "property." "The patriarchal concept of women as property lies at the root of rape," argues Mercer, which has made it difficult, even for the most well-meaning people in the slam community, to imagine Leo as the misused object (146). He is simply too big, too black, and too much like the problematic myth of the black male rapist beast to ever be a victim. His narrative is a case of community and community justice being put to the test on the grounds of race and gender. How do we practice alternative justice methods when so much of our thinking, even in radical spaces, is

caught up in racist, sexist, homophobic, classist, and xenophobic assumptions? Can we imagine an empathic, caring, working, and workable alternative? What does that look like?

Passive Rejection

Roger Bonair-Agard is a Trinidadian poet who now resides in Chicago. He began his career at the Nuyorican Poets' Café but left to help create Louder Arts, a literary and spoken word poetry collective that hosts writing workshops and a weekly reading at New York's Bar 13. Roger, with his thick beard and even thicker accent, has been an important figure in the slam world, one of the first poets in our community to nearly effortlessly navigate both the slam and the academy, the stage and the page. But in 2014, he, the official featured poet of the College Union Poetry Slam, Inc.'s annual national competition, was uninvited and had his feature revoked after a few young women, including Lauren Banka (2014), alleged that he had sexually assaulted them. In a public Facebook post that is no longer up, Lauren wrote:

Friends,

Four years ago, celebrated poet and teacher Roger Bonair-Agard abused his position as a trusted mentor to touch me sexually without my consent. I have personal knowledge of at least three other women my age, students or mentees of his, with whom he has been sexually inappropriate and/or coercive.

As you can imagine, this is difficult for me to talk about. I share it to protect the next generation of vulnerable young writers, and to encourage the (overwhelmingly male) gatekeepers of the community to examine the way they have enabled an epidemic of sexual predators.

This experience has ended my career in performance poetry, but I still consider it my community.

In the remainder of the post, she listed ways to detect possible predators and ended by stating, "Youth poetry programs in Chicago and Ann Arbor have already removed Roger from a mentorship position. To learn more about those decisions, contact me or Young Chicago Authors. . . . This statement is public—feel free to share." Since this time, many other people have come out against Roger, including the noted poet Danez Smith, who told me in 2015, "Yeah. I loved Roger too, bruh. He laid a blueprint for us. But, he did it. So fuck him."

This situation is difficult for me personally because Roger is the reason I got into slam. As the coach of the 1998 Nuyorican slam team, which won the national title, his work appeared in the team's poetry collection, *Burning Down the House*. I read the collection and subsequently fell in love with everything he wrote; and, after meeting him in 2003, I worked hard to gain his approval as a poet. To riff on a line from Terisa Siagatonu and Rudy Francisco's (2013) "Sons," a brave, brilliant, and beautiful poem about rape culture written after the Steubenville High School rape case, I will not talk about the death of our friendship without acknowledging the possible cemeteries growing inside and around the young women he may have assaulted. Importantly, I am not mentioning my admiration for Roger's work in order to simply lament a lost icon but to discuss how I, too, have participated in rape culture.

In all honesty, I have yet to engage in the narratives surrounding Roger as a sexual predator. While I have told myself in the past that I will not participate in hearsay and rumor, the truth is that, by not "doing the work," as Sam Cook might say, I and, I am sure, many others are able to keep him in a liminal space where uncertainty allows us to avoid severing ties. This is problematic. As one of the male gatekeepers whom Lauren highlights in her Facebook post, I owe women and my community much more than, at best, passive rejection and, at worst, a silent vote for the status quo.

Roger's liminality, the community's lack of support for Leo, the ways in which black males have become default predators, and the ways in which young queer poets of color have become collateral damage are stark reminders that theorizing alternative justice

methods is difficult, but living them is exponentially so. Alternative justice practices must be fluid and dynamic, always a becoming, never static, as movable as the communities themselves. The national slam poetry community has a tough task on our hands, but living, breathing transformative justice models that recognize the ways in which systems of oppression are interconnected might be a first step. Writing a three-minute poem to perform publicly has its place, and so might shaming, but doing the work—that is, learning, relearning, and reflecting on ourselves and our community in order to create "a conceptual apparatus that directly link[s] . . . our sexual assault work [with] the various political projects and leanings in our lives" is a necessary next step (Kelly 2010, 49). Putting in long hours to establish policies and procedures that recognize the failures of the court and our community to adequately respond to sexual assault is critical; but to properly address these assaults, we must understand how sexual violence is fueled by intersecting systems of oppression (Crenshaw 1989). Better still, our community needs to actively work on generating necessary conversations about rape culture and sexual violence as well as how they are linked to race, gender, sexuality, class, and institutional oppression.

As a community of performer writers, slam and spoken word poets are poised to put into operation transformative policies and practices that better address sexual assault. With our witty and often heartbreaking three-minute lectures, we "combine intellectual rigor with artistic excellence that is critically engaged," thereby refusing what Dwight Conquergood (2013) has called the "apartheid of knowledges," or "the difference between thinking and doing, interpreting and making, conceptualizing and creating" (43). We are well positioned to think, talk together, theorize, rehearse, and perform creative measures to address rape culture and sexual assault that, like performance itself, hinge on the cusp and the always becoming. Our poetic communities, which are grounded in critical creativity, are suited to push for creative policies and practices that exist beyond our current failing ones.

Like J. Jack Halberstam (2014), "I want to call for a time of accountability and specificity" in slam and spoken word

communities. While, I am hesitant to cede all "finger snapping moralism," I, too, want to "question contemporary desires for immediately consumable messages of progress, development and access." I, too, want my entire poetry community to "take a hard long look at the privileges that often prop up public performances of grief and outrage." These are difficult tasks. However, if we are committed to doing the work, then we must create committees that are trained and able to listen and weigh in on these complex matters. Committee members should not be the final voice but a group of voices that offer solutions and possibilities to better deal with the victims and the victimizers. This is a tough task, but we need to continue to work toward improved ways to handle these situations so that we are not publicly shaming newcomers, causing collateral damage, and re-creating the problematic power structures we sought to avoid within these performance spaces. In this way, we might work toward ending sexual violence in our community while pushing back against other forms of oppression and violence.

4

Button Up

Viral Poetry and Rethinking the Archives

I am so desperate to feel that I hope the technologic can reverse the universe so that the screen can touch me back. And, maybe it will when our technology is advances enough to make us human again.
—Marshall Jones, "Touchscreen"

Despite the difficult but necessary 2013 SlamMaster meeting and its fallout, the semifinals bout I competed in that year was perhaps my most rewarding. In addition to being a great bout, the poems were challenging and amazing in all of the ways typically associated with the poetry slam. The bout produced poems from me, Pages Matam, Alex Dang, and Terisa Siagatonu and Rudy Francisco, which all went viral thanks to Button Poetry, as well as dynamite performances from Clint Smith, Neil Hillborn, Rachel Rostad, Dylan Garity, and Ollie Schminkey, who all went viral with performances from different competitions.

Button Poetry is a multimodal platform for slam and spoken word poets and is mostly known for its wildly successful YouTube channel, which features a range of poets from youth slams, college slams, and various adult nationals and offers a great deal of diversity in terms of bodies and content. I currently work as a producer for Button Poetry Live and have much of my own work featured on its

channel, including "cuz he's black," a poem about how my nephew learned at an all-too-early age to fear the police, which has gone viral in the wake of the constant state-sanctioned police murder of black people. With an ever-growing list of viral poems, successful book competitions, a Twitter following of more than 20,000 people; fruitful relationships with *Upworthy*, the *Huffington Post*, *National Public Radio*, and other major media outlets; as well as a YouTube channel with a half-million subscribers and more than 100 million views, Button Poetry has shown us that it is impossible to think about slam and spoken word poetry communities without considering how they make use of virtual space to go beyond.

On Button

Sam Cook and Sierra DeMulder founded Button Poetry in 2011 as a way to distribute, promote, and fundraise for performance poetry. During a 2015 interview, Dylan Garity, Button Poetry's assistant director, said, "The original goals of Button were very small. It was very regionally based. It was all about audio, you know, producing decent audio [for poets to distribute at shows]." He told me that after "host[ing] its first recording party to produce *Button Poetry: Volume One*," an album featuring Sierra, Sam, and Dylan as well Hieu Nguyen, Kait Rokowski, Shane Hawley, and other Twin Cities poets, Button joined forces with Poetry Observed to continue to produce and film spoken word performances. In 2012, Sam and Dylan rebranded Button as a social media platform by launching a Tumblr and a YouTube channel.

Button is not the first platform to post videos of performance poetry online, but its focus on quality, close-ups, centralizing videos onto one channel, curating, and luck has made it, to date, the most successful in terms of viewership, partnerships, and income. In our interview, Dylan recounted the early days of "shaky cameras" and people "snapping and clapping" so close to the recording equipment that they obscured both sound and picture quality. He recalled how every venue, organization, college, and performance poet posted its own videos to its own channel, effectively saturating

the market. His narrative of Button's early days illustrates how the influential platform evolved through hard work, experimentation, circumstance, and luck:

> In CUPSI [College Union Poetry Slam Inc.] 2012 what we did was a little different there. We filmed . . . all of the stuff from Macalester [College] that year. . . . We kinda just filmed all of the bouts we were in . . . but we ended up putting up ten to fifteen of our favorite things we saw from that tournament. We expanded, so it was like, what if someone was just filming and not just putting up, you know, their own crew? And then we went to Rustbelt [a regional poetry slam] that year and did a similar thing . . . but we experimented [by] putting up every single thing we filmed and then [took] things down no one seemed interested in. And that was a different experiment of "Hey, let's put everything out . . . and see what happens there." And, still, we didn't set out to create a nationally and internationally known video platform. It was one of a couple of things we were doing. That same summer we ran our first book contest that Aziza Barnes won.

Dylan is a white man, and he speaks with a deep bass voice that drags whenever he moves from one thought to the next—and his mind is always moving. Before the interview, we had scheduled a brief phone meeting to discuss the project, but the call turned into a twenty-minute conversation. He told me, "People always say I go on and on, and that I ramble, so sorry about that." He was clearly excited about talking with me about my project, Button, and all things poetry, and I sense that such excitement—which is so characteristic of Button—has helped the stakeholders form a successful channel and company.

During our interview, which took place in Dylan's one-bedroom apartment in a gentrifying part of Los Angeles, we spoke about performance poetry's past, present, and future. When we finally brought the focus back to Button (I, too, am a bit of a rambler), he told me the first video to achieve viewership success was Denice

Frohman's "Dear Straight People," which reached 10,000 views in its first week (now a Button standard) after a series of reblogs and mentions on Tumblr. The second was Rachel Rostad's "To JK Rowling, from Cho Chang," an epistolary poem in which Rostad critiques the writer of the popular Harry Potter series for her benevolent and not-so benevolent racism. That same year, 2013, Button recorded and released Neil Hilborn's "OCD," a heartbreaking love poem that amassed more than 10 million views, establishing the platform as not only a power figure in slam and spoken word poetry communities but also an entity that functions somewhere betwixt and between the archive and the repertoire (Taylor 2003, 19–20).

The archive traditionally houses "supposedly enduring materials" such as "documents, literary texts, letters, archeological remains, bones," and other forms allegedly "resistant to change" (Taylor 2003, 19). It is somewhat at odds with "the so-called ephemeral *repertoire* of embodied practice" such as " performances, gestures, orality, dance, singing, . . . all those acts usually thought of as ephemeral, non-reproducible knowledge" (20). Locating an epistemic distinction between the fixed knowledge that has been legitimized in the archive and the more fluid knowledge that is performed and enacted in the repertoire, Diana Taylor argues that "performance," which for her is nonarchival, "functions as an episteme, [a] way of knowing" (xvi). Moving beyond the fact that a fixed knowledge has been, at some point, fixed by someone in particular and is therefore always fixable, we need to remember that archival practices are never clean and linear but fraught with contradictions, complications, complexities, and missing parts that both intentionally and unintentionally obstruct some ways of knowing while promoting others. The success of Button Poetry, a digital archive of an almost nonarchival material (performance poetry) collected and curated by Sam Cook and Dylan Garity, who are both straight white men, asks us to think about which slam and spoken word bodies will be deemed worthy and which will be erased.[1] Moreover, what happens when the ephemeral is documented? And how might the documented, or the archive, be little more than a performance of knowledge and power?

Like Annette Markham and Elizabeth Buchanan (2002), I see the Internet as "a social phenomenon, a tool, and also a (field) site for research." Thus, I have made use in this chapter of "digitally mediated fieldnotes" collected from public YouTube videos and comments as well as Skype interviews to tease out the tensions between Taylor's concepts of archive and repertoire and examine how slam and spoken word poetry communities make use of the Internet to go beyond (Markham and Buchanan 2002). Consequently, I extend Jeffrey McCune's (2014) "critique of [ethnographic] studies that focus on actual physical space" by taking into account how digital space, which questions and challenges the importance of the immediacy of performance poetry, allows slam and spoken word poets to extend themselves into new territory (103). Rather than finding arguments to legitimize the repertoire (though I understand the need and desire for such an enterprise), I focus on Button as a portal that allows us to see some of the ways in which the archive is always already a performance and some of the ways in which the repertoire might be fixed, however temporary and partial, for archival purposes. Button's success forces us to question how slam, spoken word, and the Internet push us to rethink what constitutes literature and how we house it.

It makes sense that a performance poetry community would make regular use of social media to display its work. Easily circulated videos allow us to feature the body not just *in* poetry but also *as* poetry. In other words, watching poets perform forces the audience to wrestle with the body of the text, the body in the text, and the body who produced the text. This conflation of the performance and the text on some level kills the inherent need for poetry books but not the need to archive.

Is the use of, and sometimes reliance on, social media a way for poets to think beyond traditional archival purposes? What can we learn from slam and spoken word poets in their attempts to create new archives? Given that one cannot critically think about slam and spoken word today without thinking of all the ways in which various poets make use of social media, how does Button allow us to reimagine performance poetry, the communities, and

ethnographic practices? By considering what Eszter Hargittai (2002) calls the "second level digital divide"—that is, one that focuses less on the binary classification of haves and have-nots in the digital arena and more on unequal user knowledge, production, and consumption—how might the virtual slam world create a "second level" of discrimination for minoritized performance poets?

From Pages to (Virtual) Stages

The poet Pages Matam was born and raised in Cameroon and moved to Washington, D.C., in 2001, when he was eleven years old. While he has since traveled back and forth between the two countries, the city and its environs in Maryland and Virginia have been his home for nearly fifteen years now. Pages is a dark-skinned young man whose outward persona exemplifies what Monica L. Miller (2009) calls "black dandyism," a political and personal sartorial performance of "black style [that] communicates moments of mobility and fixity, depending on who is looking" (3). When I first spoke to Pages, he was wearing tailored skinny jeans, a white shirt, a colorful bowtie, a dark vest, a vintage two-button sport coat, a bright yellow hankie, a black porkpie hat, and sunglasses similar to *A Different World*'s Dwayne Wayne. Always smiling, he greeted me as if we had known each other for years: "What's up, fam?" Indeed, he has been family, a brother even, ever since.

Pages, as a part of the slam group DC Beltway, has been both a national champion and a regional champion. In Washington, D.C., he has also been a youth grand slam champion and a three-time adult grand slam champion, and he coached his local youth team to a Brave New Voices International Youth Poetry Festival title. Additionally, he is a *Callaloo* fellow, has published a series of poems, has performed on TVOne's *Verses & Flow* and BET's *Lyric Café*, and is the National Fair Housing Alliance's cultural ambassador. An extremely accomplished poet, Pages is well known for "Piñata," an ekphrastic poem inspired by the artist Tina Mion's piece of the same name, in which he discusses rape and molestation in a horrifically beautiful way (Matam 2013):

To the man on the bus I overheard tell a woman in
 conversation—presumably friend:
"you are too ugly to be raped . . ."
. . . Dear man on the bus,
Tell the one in five women of this country, that they are beautiful,
their four counterparts, spared torment ugly.
Tell the one in three women of this world,
That you will not make piñatas of their bodies.
Watch morsels of them, spill greedily

By talking about rape on a global scale (including mentions of the
Mahmudiyah rape and killings), the U.S. military's "don't ask, don't
tell" policy, and the imprisonment and abuse of Elisabeth Fritzl,
Pages illustrates how the political is always personal and vice versa,
and he brings both the statistics and the cases closer to home.[2]
With a crack in his voice, he continues:

Tell my 11th grade student, Lauren
That she wanted it, her beauty had them coming.
Tell my 7th grade student Mickayla
That she wanted it, her beauty had him coming.
Tell my 3rd grade student, Andre
That he wanted it, his beauty had him coming

And just before he completely breaks, he says:

Tell the 8 year old me,
The God in me I loved fiercely was so gorgeous,
that cousin twice my age,
wanted to molest the Holy out of me,
Peeled raw
until I was as ugly as she was.

When I interviewed him in 2015, Pages told me that he wrote
the poem after being "triggered by the guy on the train." He said he
still does not remember much about the moment after he overheard

the conversation, not even how he got home. "I just remember being in my room, crying in the dark." After a pause, he continued, "And I wanted to write about it. My writing process is different now, but at the time all I knew was writing is where I go when I feel like shit. If I didn't go to my therapist, I go to my poems." Like many other poets, he used writing as a therapeutic tool. In this way, writing became a way to not only challenge the world in which he lives but also to check into another, perhaps safer, one.

Once the poem went viral, Pages received considerable attention and a number of new opportunities, but his life since then has not all been easy. In addition to becoming a face for men who have survived sexual assault, he had to shoulder the energy of the hundreds of people who emailed him their stories. "It was exhausting, fam," he said, "and not only that I had to think about my family." Speaking about how "Piñatas" allowed him to begin to write from a more open and honest place, he told me,

> I didn't even go in about everything that happened because there was still that bit of shame. When we talk about black masculinity, especially as an African male, . . . when I told my mother, I want to do creative writing, like I'm not gonna be a doctor anymore, I wanna write and teach and stuff like that, I got disowned for a year. Like poetry does not pay the bills. Poetry is something women do, it is not a real man's job. Writing that single line was hard. That line of "tell the 8 year old me" was the toughest thing I ever had to write. Ever. Because I was not sure how it would be received. You know, the whole thing about how people think men don't get raped.

Pages shared with me some of the details of his story that he intentionally omitted in his poem. We talked a great deal about how infuriating it is to make choices that place our family's comfort over our own health and how, in an anti-black world, their comfort and our health are not always mutually exclusive.

Pages, however, is not alone in making these tough choices. Janae Johnson, a queer black woman from northern California

who now resides on the East Coast, told me that she denied Button's request to post her poems online due to professional and familial concerns. Janae, whom I call my cousin because of our last names and our similar sartorial choices, won the 2015 Women of the World Poetry Slam and the 2015 National Poetry Slam. She started the House Slam in Boston with Porsha O., the 2014 Individual World Poetry Slam champion, after a series of sexist and homophobic moments that left them in search of a more inclusive space. In one of those moments, a straight black male poet openly mocked Janae's poem about being a butch black woman. No one spoke up in her defense because all the poets claimed the mocking was a practice of free speech, despite how unsafe she felt. But with the House Slam, created by queer women of color, Janae and Porsha were able to best everyone. The venue is evidence of the continual need and desire for counter-spheres, even within counter-spheres.

Janae told me that she "kind of fell into poetry." In our interview, she said, "I have nothing against Button . . . but I kinda feel weird about having my [poetry] accessible." As we spoke about the immediacy of live performance, she told me she feels a certain level of "vulnerability . . . [about] the poem being online." Those of us who have gone viral know what it is like to be made continually open for an ever-growing audience, to deal with a mixture of online trolls, cult-like celebrity, expectations that we will be figureheads for a movement, and the commentary of those who overly dissect the poet and the poem. Even more worrisome is the way in which a viral poem may affect home and family. As Pages said, "It was less scary that the poem went viral; it was more scary that my family was gonna see the poem and then my family is gonna ask me questions, because my family don't know. My mother knows, but she only knows about the girl," not about his stepbrother, who sexually assaulted him during the same year. The incident did not appear in the poem because, as he explained, "that's a whole other level." He notes that, when you think about black masculinity through an African lens, an assault by an older brother problematically positions the victim as unmanly.

Alex Dang is a college student who is best known for his poem "What Kind of Asian Are You?" After calling out his parents in another poem that was making its way around the Internet, he took part in some tough but necessary conversations with his family members. During a 2015 interview, he said, "When my brother saw it, . . . me and my family, we all sat down and we did talk about it, . . . and we had a big long conversation so we're better about [it] now. . . . They're still hurt, and I'm very sorry I hurt them like that." Jesse Parent, a white male whose poem "To the Boys Who May One Day Date My Daughter" led to comments suggesting that he wants to sleep with his own child, told me, "Look, I can handle a troll, but my daughter can actually read some of this sick stuff." Because of such reactions, many poets have become "very self-conscious," as Janae says, about the poems they allow Button to post, and that awareness is always complicated by race, gender, sexuality, and class.

In his study of Detroit ballroom culture, Marlon Bailey (2013) details "the propagation of a particularly mythical notion of the Black family," which was a practical response to and internalization of the infamous Moynihan report, a racist and sexist 1965 document in which the assistant secretary of labor, Daniel Patrick Moynihan, argued that an increase in single black mothers was due to ghetto culture and pathological black women, and intersectional oppression more generally (83). He argues that the black family adopted compulsory heteronormative gender and sexual relations that, in turn, created black familial spaces in which "Black LGBT people are not necessarily able to rely on, have full access to, or be safe within Black homes" (84). This situation is critical because, in an anti-black world, the black family is one of our few safe havens from white supremacy. While black LGBTQ people have created alternative families within ballroom culture, spoken word poets, many of whom identify performance poetry spaces as safe havens, are still struggling with the digital version of safety. Thus, they have mixed feelings about how Button uploads the so-called ephemeral, live poetry into an easily accessible archive.

Janae is an associate athletic director at a university and, as a queer black woman, worries that publicizing parts of her identity in poems might hinder potential employment. She intimately understands the trap of visibility (Foucault 1977), and her dilemma offers us another way to think through what McCune (2014, 6) calls "discreet life." McCune is primarily concerned with the down low—that is, black men who sleep with men but otherwise lead straight lives—as a politics, a way of being, and a site of generative possibility for those "who seek agency under the constraints of surveillance" (8). Yet Janae's sexual and poetic discretion reminds us that black queer women also engage in passing politics. As she told me, "If they Google me and the first thing that comes up is a sex poem, they'll be like, 'I ain't hiring you.'"

Black queer women and black trans folks are uniquely caught up in institutional and familial surveillance and are often the most vulnerable populations. Given the ways in which their gender, race, sexuality, and class collide in a nexus of systemic oppressions, they have always had to develop strategies to navigate unfair and unsafe spaces and regulatory practices. The journalist Ben Penn (2013) reports, "The jobless rates for blacks and Latinos outpace the rate of the overall population, but the difference is especially stark among LGBT workers of color." He goes on to note, "Within the LGBT community, transgender unemployment was even more pronounced."

Despite her concerns, Janae gave me permission to use her full name and to share our interview because, "with all the stuff that is going on right now with black bodies, . . . it is important for me to leave something." What she means by "stuff" is the legalized killing of black people by the police and extralegal forces . . . Sandra Bland, Trayvon Martin, Freddie Gray, Michael Brown, Tamir Rice, Ayana Jones, Renisha McBride, and far too many others . . . that have triggered a national discourse. Her reasoning answers Richard Iton's (2008) question: "How do the excluded engage the apparently dominant order?" (3). For black people, "partly because of their marginal status and often violent exclusion from the realms of formal politics," the arts and popular expression have

been especially important in shaping the black political landscape "throughout the pre-civil rights era and the civil rights era itself" (6). Janae has recently given Button permission to share her work, albeit under the pseudonym "J. Johnson," because she understand how intimately intertwined the arts and politics still are for black people and also knows that some continue to find formal politics uninviting. In a moment that has given rise to #blacklivesmatter, #sayhername, Gloss Rags, verysmartbrothas.com, and other critically creative or creatively critical movements, black spoken word poets are penning thousands of poems that refuse any distinction between art and activism, between the popular and the political.

Janae also reminds us that, for women, black women, and black queer women, "poetry is not a luxury" but "a vital necessity of [their] existence." Janae's need "to leave something" is more than creative word play from a living black body in a world that is obsessed with black death. It is a language that expresses a "revolutionary awareness and demand" for freedom, for something more, from both formal and informal political structures (Lorde 2007, 372). It recognizes a way to freedom that calls out white supremacist structures as well as black revolutionary spaces that are unsafe because of racist, patriarchal, and homophobic practices. Janae's "leave something" is "taking the stance that black women exist—and exist positively" (Hull, Scott, and Smith 1993, xviii). And because "Black men have remained blind or resistant to the implications of sexual politics in Black women's lives," her move to allow Button to post her work is also a necessary response to how the state oppresses queer life and women life as well as the ways in which black men have oppressed black women and queer folks (xxi). With black death looming so heavy, and how we care less about the death of black women, black queer folks, and our black trans siblings, her "leave something" works to make a safer and more radically inclusive house, to create a means to continue, somehow, beyond this moment. It is a critically creative attempt to escape being trapped between financial and physical security, a choice that women of color—trans, queer, straight, and otherwise—are forced to make far too often.

Janae's "leave something" illustrates how Button's digital platform is simultaneously problematic and potentially transformative. Button allows her to connect with other black queer women beyond the physical poetry venue who may not have had access to someone who speaks so boldly about their realities. Thereby, it helps to create life-saving and affirming connections while exposing her and her work to the larger racist, patriarchal, and homophobic world she at times critiques and speaks back to and at other times seeks to avoid altogether.

Multiple Digital Divides

Now that Button is able to broadcast our poems to the virtual stage, the slam space has been forever changed. What was once a specific physical venue in which people shared their most difficult thoughts is now open to millions. Button does always ask for contractual permission to upload poems, and poets have always had trouble deciding what and how much to share. However, the platform's success, as well as who is running it and the ensuing and inevitable divides, makes these decisions weighty. As Danez Smith told me, Button's decision makers "are some young white dudes learning and like fuckin up sometimes. And I haven't always agreed with the politics, or things that they've done." Danez's first book, *[insert] boy*, won the Lambda Literary Award for gay poetry in 2014. He is a Ruth Lilly and Dorothy Sargent Rosenberg fellow, a Cave Canem fellow, a two-time Rustbelt champion, and a two-time Individual World Poetry Slam finalist. Accomplished, witty, brilliant, brave, and, at times, scathing, Danez describes himself as a "Black, masculine but not quite male, queer, ma'fucker."

Like Button, Danez is based in the Minneapolis area and is regularly featured on Button's channel; the company has also published his book *Black Movie*. A friend of many people in the organization, he danced around his critique of them during our interview, asking himself, "How real do I keep this?" whenever I pressed him on the matter. He mostly spoke of Button in vague pronouns, though he did call out its "education initiative that was

really impeding a lot of work done by people of color." Without providing any substantive details, he told me that they were "white boys trying to move in a colored area, . . . but, no, I don't think [I'll share any opinions]."

Danez believes that Button has grown from its past mistakes and that it is generally doing important things for poetry, but many other poets think the fact that the company responsible for popularizing performance poetry in the digital age is headed by two white men is inherently problematic While no one spoke to me openly about their issues and concerns, mainly because many see the organization as their primary avenue toward success, the owners, Dylan and Sam, both told me that poets had accused them of being racist, sexist, or operationally worrisome. Yet Sam said that, even though he welcomes criticism, he rarely hears it:

> I don't have a lot of conversations with people who think we are the worst thing happening to slam . . . and I really regret that. And that's how the world works. Those people are gonna not choose to spend their time communicating with me. The big downside of that is I don't get to hear those critiques and I can't act on it, you know? I go out of my way to find those critiques of how Button functions, . . . but at some degree if you can't get people to bring their critiques to you in some fashion, you can't build in way that is safe, . . . and that's on my end as well.

Both Sam and Dylan, and Button by extension, are well aware of how they are seen, and they have worked toward becoming a more socially conscious company. In an interview, Jesse Parent, a white male with a theater background who works in Salt Lake City as a software manager, told me, "I know for a fact Button's main goal is to be a more diverse voice, [but] . . . their top most-posted authors . . . [are] heavily female [and] heavily white. . . . So that's just Button curating." However, my recent visit to Button's channel showed that, as of the summer of 2016, it features twenty-one videos by Neil Hilborn, sixteen by Hieu Minh Nguyen, fourteen by Sierra DeMulder, fourteen by Danez Smith, thirteen by Sam

Sax, twelve by Desireé Dallagiacomo, twelve by Anna Binkovitz, and eleven by Hanif Willis-Abdurraqib. That list of poets includes three white women, two white men (one of whom is queer), a queer Asian man, and two black men (one of whom is queer). Clearly, Button, on some level, is actively working toward diversifying its YouTube channel.

Yet while I agree that Button has its heart in the right place, as is particularly apparent in its new efforts with Twitter's direct video player, I also understand poets' larger concerns.[3] As one poet, who wishes to remain nameless, joked, "Yeah, we need Button, but it depends on who controls the button factory." This is what Hargittai (2002) calls the "second level digital divide." Many poets question Button's production choices, effectively challenging the "differences in Internet users' online [production] skills" (Hargittai 2002). While most of the research around the digital divide has largely centered on understanding consumption—that is, who has Internet access and who does not—a few scholars have begun questioning who creates and controls digital content (for instance, Hargittai 2002; Correa 2010). Jen Schradie (2011) argues, "The Internet has, indeed, expanded the opportunity for Americans to contribute to the digital public sphere." (165). But while social media sites have grown, "the poor and working class have not been able to use these production applications at the same rate as other uses and users, creating a growing production divide based on these elite creative functions" (166). In other words, while poor and marginalized communities use the Internet in creative and empowering ways, they have done so primarily in consumer roles.

Minoritized poets are growing tired of always being the product and, in true Motenian fashion, are speaking back. "The history of blackness," writes Fred Moten (2001), "is a testament to the fact that objects can and do resist" (1). As in the case of Button, black poets in the slam and spoken word scene are tired of being mere products or poetic objects for white consumption and are searching for ways beyond even new media modes of re-presentation. Shihan and Dante Basco, along with DPL, have teamed up with the hip-hop mogul Russell Simmons to launch the platform All Def Poetry. This

is not a direct response to Button, as DPL previously attempted a collaboration with will.i.am of the Black Eyed Peas in a social media site, Dipdive, that has since failed. Amir Safi has created Write About Now, a series of social networking and interactive platforms primarily focused on poets from the South and derived from the Houston open mic spot of the same name. Lindsey Michelle of Rutgers University has created a relatively successful YouTube channel that promoted the content of her university's collegiate slam poetry team and others. Jamaal May, a black male poet from Detroit, has created and manages Organic Weapon Arts, a chapbook and video series that works with artists such as Rachel McKibbens, Ross Gay, and others. Although they did not create these enterprises strictly in response to Button, these minoritized poets are doing the work of institution building beyond.

They are also guarding against another "White Bloody" situation. In the mid-2000s, before poetic Internet success was as important as it is now, obtaining a contract with Write Bloody Publishing was the pinnacle of achievement for many poets in slam and spoken word communities. Founded in 2004 by Derrick Brown, a white male poet who now lives near Austin, the press was, from the onset, criticized for not publishing much work by poets of color. During the 2008 National Poetry Slam, after we learned that we would receive copies of Write Bloody books, one poet yelled out, "Don't you mean White Bloody?" Even now, the press's list of authors reads like a who's who of white slam and spoken word poets. The frustrations of many poets of color, especially those of black poets, have arisen not simply from Write Bloody's lack of color but its structural disavowal of a black aesthetic that it sees and constructs as unworthy of its archive.

Mahogany L. Browne, a renowned poet and teacher, founded Penmanship Books because "the hierarchy of the literary world [is] painfully silent and unyielding" (Penmanship n.d.). Penmanship authors are primarily black women but also include black men, Latinas, and LGTBQ folks. It is a brilliant example of how a black woman can create a company for otherwise silenced and unsupported voices. Browne has proven that minoritized subjects will

always find ways to create, re-create, alter, challenge, and refill an archive, reminding us that it is simply an archive, not the archive. Like May's Organic Weapon, Safi's Write About Now, and other platforms, her press demonstrates that archives are fixable and flexible sources of knowledge and that those who construct them as concrete entities are working to sustain certain power structures. Despite the discourse that suggests that the digital arena is democratizing, digital access is constantly shifting in ways that disavow equality and radical democracy. Access is not a static concept but is dynamic and always moving. It is an ongoing process, a negotiation, even a continuous battle.

Unbuttoned

People of color have always found access to the digital arena, whether though mobile phones or public libraries; but today's spoken word poets have become increasingly focused on producing, building, and owning a lasting digital presence on their own terms. Nonetheless, only a few have cultivated a large online following or achieved viral success outside of Button. One of them is the San Diego poet Rudy Francisco. I met Rudy in 2006 when we were en route from southern California to a show in Las Vegas. I was in need of transportation, so the Pomona poet Tamara Blue introduced me to Anthony "Ant Black" Blacksher and "the San Diego boys," as she dubbed them. Ant Black, Rudy, and Kendrick Dial would all be in the show with me, and Chris Wilson, the co-founder of Elevated, San Diego's most popular bimonthly open mic and slam, drove us all there. At that time, I was already a two-time national champion and an HBO Def Poet, so they were all well aware of my work and me. Throughout the trip they asked me questions about poetry, DPL, the national community, and slam. The experience was one of my most memorable as a poet, mainly because I immediately connected with a group of people I had just met and I was reminded of the potential and possibility for healthy community. Ant Black and I were the headliners at the show, but I also remember thinking to myself, Rudy is going to be really good someday.

Rudy is an American-born Belizean poet who quit his graduate program in Industrial and Organizational Psychology to pursue poetry full time. He wears tailored clothing ,bowties, always has a clean lineup, and is so conscious of his appearance that Shihan calls him Never Crease. I, too, am a neat freak, and Rudy and I both joke a lot and share almost identical aesthetic and sartorial tastes. He has become my brother. We speak together almost daily, discussing politics, fears, goals, desires, relationships, and a host of other topics, and we have always supported one another, even when in competition. Rudy and I are "heterosexual black male writers who have been willing to embrace the gray areas of black masculinity in ways that collapse rigid perceptions of black heterosexual identity" (Neal 2005, 28).

Rudy is the 2009 National Underground Poetry individual champion and the 2009 individual World Poetry Slam champion. He tours as a poet nationally and has appeared on *Verses & Flow*. A member of the spoken word collective Fiveology, he is also a successful self-published author, and his first full-length book is forthcoming from Button. Rudy got into writing after watching *Def Poetry Jam* on HBO and seeing the poet Amir Sulaiman perform live. He told me during a 2015 interview that he established an online presence in ways that were similar to Button's. He was one of the first poets to upload a professionally shot and edited poem on YouTube. Titled "Love Poem Medley," it was "a very tangible love poem," filled with quotable punch lines such as "I want to be your ex-boyfriend's stunt man. I want to do everything he never had the courage to do like . . . trust you." I have seen him perform it dozens of times, and it has never failed to register with the audience. The recorded performance, which has been shared via numerous social media sites (and undoubtedly by email as well) allows people to live and relive the performance moment, establishing a kind of "imagined community" (Anderson 2006, 6).

"Love Poem Medley" helped Rudy establish his online presence and, like Neil Hilborn's "OCD," another easily accessible love poem, it laid important virtual groundwork for Button Poetry. Both Rudy and Button expanded the slam and spoken word poetry

communities, not simply by posting videos but by publishing high-quality content that made the audience feel both in the room and part of a community. Both also owe a great deal to accessible love poems, using them to establish virtual spoken word venues and communities for people who, in Rudy's words, "sometimes have no access to live poetry." The importance of this point cannot be overstated. Rudy himself began writing in a small imagined community made up of *Def Poetry Jam* clips and an Amir Sulaiman poetry album. Considering the power of virtual poetry, he told me, "I think it's beautiful. It's amazing, because I don't know who I would be if I didn't have access to poetry. I'd be a completely different human being." Yet he recognizes the complexities as well. "Our community has given being on Button this status symbol that I think is a bit inaccurate. To me, Button Poetry is an open mic on YouTube. You have people on it of various skills levels . . . speaking on various topics. . . . It's a representative sample of what you might see at a . . . national reading." Rudy's description of Button as a virtual open mic highlights the platform's important role in opening the poetry room and expanding the audience. It also points to the symbolic currency attached to Button, which in some ways drives creativity and inhibits free discussion in slam and spoken word communities—not least when poets refuse to speak critically of the organization. Most importantly, Rudy's description helps us think about how virtual and physical poetry spaces are trapped in politics that are similar to those in the larger world.

In 2014, shortly after the police officer Daniel Pantaleo murdered Eric Garner in broad daylight, Rudy tweeted about the incident, using the statement "murdering unarmed black bodies," and received an enormous backlash from his fans. "That was one of the most surprising moments of my career," he said. Rudy's largely white, college-aged, female fan base was surprised that this supposedly apolitical love poet would tweet about his love for black lives and black safety. Rudy, who was smart and surgical in his responses to their tweets, told me, "That moment forced me to rethink my larger body of work. I cannot understand how people can love my work, but not love all of me. Yes. I write love

poems, but I am black first." The moment also illustrates the ways in which blackness is silenced, even in supposedly radical arenas such as poetry slams and virtual space. The digital world, with all of its potential for subversion and radical democracy, is rife with the same issues as its physical counterpart.

Indeed, this is why so many slam and spoken word poets are asking, "Where is the virtual space for women of color?" A quick survey of Button's YouTube channel reveals that, of their twenty-five most-watched videos, only two feature a black or a brown woman: Venessa Marie Marco's "Patriarchy," which ranks four-teenth, and Tonya Ingram's "Thirteen," which ranks fifteenth. Sam Cook is aware of this discrepancy. He told me, "Women, especially over the age of the thirty-five, and not just women of color [but] specifically black women, have the least amount of traction on the channel." He believes this mostly has to do with Button's largest fan base, girls and women ages "thirteen to twenty-four [and] . . . probably predominately white."

Tonya, a Bronx-born poet, is the only woman of color in the slam world to amass more than a million hits, which she did with her *Buzzfeed* collaboration about her depression. A collegiate slam champion, she was a co-founder of the New York University Slam and has been featured on *Afropunk*, *For Harriet*, the *Huffington Post*, *LupusChick*, and *Upworthy*. Tonya is humble and reserved but, once comfortable in a conversation, becomes brilliantly and beautifully weird. "Poetry was the imaginary friend I had growing up," she wrote in a 2015 email interview. "I'm not very social. I'm quite quirky and I just found that writing got everything I wanted to say right. I feel a certain undeniability as a poet. I am confident as a poet."

Whatever confidence Tonya lacks in social or personal settings, she more than makes up for on stage. To witness her perform live is to finally have proof of God, yet she is aware that some audience members are unsettled by her. "Sometimes I think it is because viewers may not feel they can relate, or the way I embody perfor-mance poetry may be viewed differently than how a non-person of color is perceived. I once had someone tell me that I am always

angry in my work, which I think is untrue. I am exhibiting an act of vulnerability, which unfortunately gets mistaken for anger." Being reduced solely to anger is "political," writes Melissa V. Harris-Perry (2001) "because black women in America have always had to wrestle with derogatory assumptions about their character and identity" (5). She continues, "These assumptions shape the social world that black women must accommodate or resist" (6). Labeling Tonya solely as angry, as someone incapable of other emotional possibilities, is a reflection of the white imaginary. Whiteness is unable and unwilling to read Tonya in any other way because it cannot understand, or perhaps refuses to understand, how she and other black women resist and shape their own social worlds outside of white supremacist logics.

I am not suggesting that anger or rage is inherently problematic. Rather, riffing on Mark Anthony Neal's (2013, 4) concept of "illegible black male" bodies, I suggest that the ways in which black women are made legible in a white male public sphere is problematic, serves the nation-state, and is a major reason for why black women's work is not going viral at the rate of white men's, black men's, or white women's in the virtual slam and spoken word community. These preconceptions deny black women nuance and complexity and rhetorically construct them as not yet fully evolved. They serve the nation because they shape black women as perpetually irrational beings, always in need of surveillance, control, and intervention. They disallow black women digital visibility in slam and spoken word and thus erase their voices in the digital archive by dismissing them as underdeveloped ranting, even though constant rage is a legitimate reaction.

According to Soshana Zuboff (1988), "it is necessary to consider both the manner in which [technology] creates intrinsically new qualities of experience and the way in which new possibilities are engaged by the often-conflicting demands of social, political, and economic interests" (389). Rather than arguing that Button is racist, sexist, or heterosexist (which, in my opinion, it is not), I want to point to some structural issues. Given Button's aforementioned fan base, with about "70 percent of its audience women thirteen to

twenty-four," we can see some trends. Sam told me, "Young people or people that are perceived as younger are more successful. People that are talking about women's issues, or women, are more successful." The demographics of this fan base forces us to think about the politics of consumption and production as well as Hargittai's (2002) "second level digital divide." Dylan showed me emails in which Button had urged a couple of its media partners to promote a more diverse group of poets. Yet the channel is produced by white people, in partnership with mostly white media outlets, and consumed largely by young (probably white) women. When we couple these facts with how whiteness is unwilling or unable to empathize with black women or allow them nuance, we cannot be surprised if black women are constantly denied full access to Button's digital sphere.

I agree with André Brock (2012), who writes that "Black Twitter confounded" the belief that social media is almost always dominated by white participation and that "White participation in online activities is rarely understood as constitutive of White identity" but "as stuff 'people' do" (534). While Brock provides a nuanced reading of Black Twitter as a public unto itself, the platform's very in(ter) vention, which by definition is an/other space, is a reminder that Twitter has been constructed as normatively white. Likewise, 4chan, a popular networking site that relies on an image-based online bulletin-board system, registers its users as "anonymous," or "anons." Presumed women sometimes "come out," for a number of reasons, as "femanons," which means that the supposedly neutral anon is in fact always already sexed as male. Whatever inroads these groups have established are important and deserve attention, but they are also stark reminders that the Internet is a raced and gendered space that at times is liberatory and at other times oppressive.

Suggesting that the Internet is democratic without critically examining the means of production is ahistorical and ethically specious. If the means of production is still largely controlled by white men, even well-meaning ones, and the audience is largely white women because history has set up an unequal distribution of goods, then the Internet is grounded in neoliberal logics dressed in

a radical democratic garb. By neoliberal, I refer to the philosophy of equal access to the free market, which is neither free nor equal, and that all goods and services, regardless of their social, political, and personal importance, are subject to greed-driven ownership and unequal forces. Neoliberalism is an unimaginative mode of seeing the world and all it has to offer in market metaphors, reducing us to "individuals *against* collectivities," an assumption that "works itself out as caring about me and mine, of course, at the expense—unhappily, even—of others," while reducing everything, including necessities such as health care and education, to nothing more than consumable goods (Crawley 2015).

It is well documented that access to the Internet and to modes of production are unequal and unfair. While the Internet has radical potential and spoken word often realizes those possibilities, I cannot dismiss the fact that unequal modes of production and consumption—informed by historical, economic, political, and social forces and imbued with limiting assumptions about race, gender, sexuality, class, and age—have not established a free system so much as a system that freely seeks to erase the voices of black women. The Internet allows us to be simultaneously producers and consumers; it allows us, to borrow from Foucault's (1977) logic, to be in the cell and the panoptic tower. And, it is here, in the in-between spaces, the both-and spaces, that we might work to produce a kind of archive that seeks to be radical, democratic, inclusive, and polyvocal.

Beyond the Button

The frustration about and reverence for Button Poetry in slam and spoken word poetry communities is informative. On one hand, the camera in the room expands the audience for poetry, provides new means of witnessing it, establishes a robust archive, creates new opportunities, and continues the important work of institution building beyond. Some poets work toward having a piece on the channel with hopes of growing their own fan base, being offered new shows and writing opportunities, and gaining the respect of

their peers. On the other hand, while Button creates new possibilities, it simultaneously forecloses others. The ubiquity of cameras in this changing digital age does not make people forget they are being watched. In fact, we become hyper-aware. As the anthropologist Lanita Jacobs-Huey (2002) reminds us, "the natives are gazing and talking back" (79).

What was once a room where politically and personally vulnerable poetry could be shared—a sort of confessional booth—has been transformed into a space in which the confession and the confessing body can be archived. Sharing vulnerable and volatile work is already a difficult choice, despite how necessary and life saving it might be, but it is even more complicated when Button enters the picture. During the 2015 Individual World Poetry Slam, I was forced to make a tough decision. I was one of twelve poets to get to finals, and PSi requires that all final stage performances, as recorded by Button, be uploaded to its channel.[4] I wanted to perform what I felt was an important and necessary poem, but I did not want it on YouTube. While Button would have gladly not uploaded the performance, PSi, thanks in part to the platform's success, would not budge. I chose instead to perform a different poem, and I wondered the entire night about what had happened to a space I had once thought so sacred, a space I had once thought was, above all, about poetry.

Button's position as *the* digital outlet also frightens poets in another way. The fact that no one wanted to speak on the record about their frustrations with Button speaks volumes about the power relations in the slam community. What does it mean when bold black and brown poets are afraid, out of concern for their livelihoods, to speak openly about a couple of white guys? Some of that fear is grounded in friendship, but as a poet who wished to remain nameless told me, "Yeah, I have concerns about Button, but I also want to make sure my bread is buttered." In short, many poets have justifiable worries about how they will appear, or if they will appear at all, in the budding performance poetry archive. They fear that the beyond will not deliver on the promise of new freedoms but reproduce the same old mechanisms of oppressions.

That Button, one small but profound company, has so much symbolic and actual clout is disturbing, and I think poets have every right to question the platform's position of power, how it uses that power, and the fact white people are primarily in charge. Historically, the slam and spoken word communities, which exploded the almost always white male–authored text, have been easy to join; but as we continue to archive the work of these performance poets, we must think about how archival practices are raced, gendered, and sexualized and how we might be in danger of producing the same power structures that so many poets speak against. Employing me, a black male, is one step, but Button also has to figure out ways to forge relationships with media outlets that are not dominated by white producers and audiences. Verysmartbrothas.com, the Crunk Feminist Collective, World Star Hip Hop, the *Root*, Latina.com, the Bad Dominicana, and Ain't I Latina? all come to mind.[5] These partnerships could not only prove useful for the digital success of poets of color but, by coloring the audience, might also color tastes and affect what is considered good poetry. Recognizing that the archive is little more than a performance of power, we must work at the levels of both production and consumption to ensure that slam and spoken word is radically inclusive, re-presented in full and dynamic ways, and becomes an archive that is forever in search of something beyond.

5
Conclusion

"That Is the Slam, Everybody"

I will take one of the flowers I've been saving for my casket
and stick it in my hair the way my mother used to do.
—Imani Cezanne, "Flowers"

I woke up early on a sunny summer day in Chicago in 2010. I had flown back to the city for my dissertation defense and was staying in what was affectionately known as "the Poet House" in the city's Albany Park neighborhood. I put on a single-breasted, two-button suit and then stepped into the living room to greet my fellow poets. One of them, Ebony Hogan, said, "You look nice. If I was on your committee, I'd definitely pass you on the suit alone." Ebony, along with Roger Bonair-Agard, J. W. "Baz" Basilo, Emily Rose, and Stacy Fox, was living in the house at that time. The group held a monthly poetry reading in their large living room and often housed visiting poets. The place was also known as "the Real Talk House," given the rambunctious cast of characters who lived there. On that sunny morning they were subdued but ready to see me off and wish me luck.

I remember thinking that the diverse house was a pleasant reprieve from Chicago's otherwise segregated poetry commu-nity. I lived there from 2005 to 2007 and from 2009 to 2010 and

remember it as "a city divided within itself" (Abu-Lughod 1999). When I think of Chicago, I recall the lake in early spring, traveling on the Red Line, the blistering cold, the robust art scene steeped in a history of radicalism, the summers—oh, the indescribable summers—and the food. I also recall a slam and spoken word poetry scene that was similar to the city itself, with its "widening racial and class rifts." Chicago, with its robust theater, jazz, and blues communities, has a deep arts and entertainment tradition, so it is easy to assume that its slam venues would attract diverse performers and audiences. Nothing could be further from the truth: that community hides what Janet Abu-Lughod calls the "backstage city" while highlighting its "glorious lakefront façade" (321).

In using these terms, Abu-Lughod (1999) is speaking of a "Postapocalypse Chicago," one that by the late 1960s had begun to struggle economically, in which racial tensions were "explod[ing] in violent protest . . . ignited by the assassination of Martin Luther King Jr." and "fed by the frustrations of the neighborhood's impoverished black residents" (321–22). As a constructed face, the "glorious lakefront façade" has fed off the masked "backstage city" even as the backstage has hidden the façade's dirty work, helping it to maintain an illusion. In the case of the city's slam and spoken word poetry venues, organizers have on some level maintained the façade of harmonious diversity, while pushing its racial rifts backstage.

I first visited Chicago in August 2003 as a member of the Los Angeles slam team. That year, PSi had elected to adopt a five-team-per-bout system to accommodate an unusually large number of applicants. Now, because of the new structure, coupled with the large number of teams competing, it was numerically possible to win both preliminary matches and still not make it to semifinals. So while fear of failure is always present in competition, it was all the more palpable that year. Nonetheless our team—which also included Sekou "Tha Misfit" Andrews, Steve Connell, Sam "Buddha Hat" Scow, and our coach Damon Rutledge—was determined and well rehearsed.

The summer air was thick and humid, and we were filled with an electric excitement. I remember marveling at the city's old

buildings, some of which seemed older than Chicago itself. As I traveled on the El from the West Side, to the Loop, to Wicker Park and further north, I felt as if I were tracing the footsteps of Preach and Cochise, the main characters in the 1975 film *Cooley High*.[1] I was excited to perform in the city where Darius Lovehall, the poet-protagonist of the 1997 film *Love Jones*, shared his "Blues for Nina," a piece that was actually written by the Chicago poet Reggie Gibson. Even more, my teammates and I were elated about the idea of returning to the birthplace of slam in an attempt to win the big one.

Visiting Chicago in the summertime is like living inside the Kanye West track "Good Life."[2] The streets were filled with festivals that celebrated various cultures, various foods, and all things Chicago. I was awed by this meat-and-potatoes city, many of whose citizens are the hardworking descendants of a barrage of ethnic groups who came in search of factory jobs. Little did I know that two years later I would move here to work on my Ph.D. at Northwestern University.

While I was extremely excited about making this change in my life, Chicago's winters were not nearly as pleasant as its summer had been. A new down jacket could not keep this L.A. boy enthused about living in an urban tundra. Nothing could prepare me for the sensation of waiting for a train on a raised platform in a Windy City winter breeze (Abu-Lughod 2000; Charles 1933). Nor was I ever prepared for the chill of Chicago's particular brand of segregation. Of course, it is not the only major city to engage in separatist politics. But while both Los Angeles and New York have their segregation issues, Chicago's segregation has spilled into its poetry scene in unique ways (Abu-Lughod 2000). It may be that New York's congestion does not allow for such visible kinds of segregation; perhaps the separatism in Los Angeles is masked by its car culture, which gives citizens immediate access to all parts of the city. Whatever the reasons, Chicago's brand of segregation has become so entrenched that its nationally known spoken word poets often do not recognize one another because one is white and the other is black; one

lives on the North Side, the other on the South Side. Robbie Q. Telfer, a white male poet and the former performances manager for Young Chicago Authors, told me in a 2007 interview that, while he had heard of Red Storm, a black male poet from the South Side, "[if I] saw him I would not know who he is." Red Storm agreed, telling me in his own 2007 interview "I don't go to the North like that." Likewise, Stacy Fox, a young white poet and a teacher in the Chicago public schools, told me that year, "When Roger [Bonair-Agard] came to do writing workshops for my classes, I told them we share a house on the North Side, and they didn't believe me. My students on the South Side still think I am lying to them about Roger living with me. They told me that he does not live with me, and he does not live on the North Side."

Chicago poets are familiar with the assumption that blacks stay on the South Side, whites on the North Side, and blacks and Puerto Ricans on the West Side. The Uptown Poetry Slam, held every Sunday in the North Side's Green Mill, is primarily filled with white poets and audience members, whereas Ritual Rhythms, held every Sunday in the South Side's Negro League Café, is as black as its name.[3] The segregation in the poetry scene made it difficult for me to find a Latinx venue, let alone recognize it or its regulars by name. Only Young Chicago Authors, which serves the city's young writers, is working to change Chicago's separatist practices, which are deeply knotted to the politics of space.

Dr. Robert S. Boone founded Young Chicago Authors in 1991 with the idea "that young people should have more exposure to creative writing." It began by offering "an intensive three-year" program for young people, who after graduating from high school "would [then] receive $2,000 per year for college." In 1995, the organization converted the second floor of a Wicker Park apartment building into its headquarters and started offering year-round activities for students. By 1997, YCA's budget had nearly doubled to $145,000, and "750 students [were taking] part in programs annually." Most of them were "living at or below [the] poverty level with 40% from African American and [another] 40% from Latino households." Today, YCA serves "2,500 teens a year

through workshops, performances and publication programs" (Young Chicago Authors n.d.). It recently received a grant from the MacArthur Foundation, and it estimates that it now reaches 30,000 people in Chicago and beyond through its readership and events.

I first visited YCA in the winter of 2006. Braving the cold to get there, I found myself in an ample, brick-walled, open space. Old bedrooms now serve as small offices. There is a kitchen that usually provides food after workshops and a bathroom with chalkboard walls where young artists are encouraged to express themselves. Their serious and silly metaphors made excellent restroom reading and seemed to symbolize the place's bubbling warmth. As I walked up to the second floor, I was met with excited faces, laughter, handshakes, yelling, running. A student named Tim "Toaster" Henderson, who is now a well-respected adult poet, shouted, "Awww! Javon Johnson is in the house!" Spending an evening with those talented young people was a refreshing reminder of the frenetic energy that is one of the best parts of contemporary slam and spoken word poetry venues. They reminded me of why I began writing. Aside from their buzzing high spirits, the ways in which they used their artistic abilities would have made any scholar of performance proud, and they dealt with a range of topics: politics, love, sex, violence, war, race, gender, class, music, home, and many others.

Nate Marshall and Demetrius Amparan's co-written poem "Lost Count: A Love Story," chronicles the rash of violence in Chicago and is a painfully beautiful example of how YCA young artists have used their poetry to make sense of their lives. Nate and Demetrius are both from the South Side. Nate went on to graduate from Vanderbilt, Demetrius from Valparaiso, and Nate now holds an M.F.A. from Michigan University. Today they actively work as teacher-artists dedicated to eradicating violence through artwork that critiques larger structures of inequality and works toward other possibilities. In 2009, I interviewed Nate as a college sophomore, and he told me, "A lot of us who were on the [youth slam poetry] team kind of had personal, you know, encounters

with, . . . I guess, that legacy of violence." Robbie Q. Telfer, who had once been Nate's old slam coach, substantiates that comment, adding, "Sharreef, one of our guys here, had to carry a box cutter just to go home."

I frequently held poetry workshops on the South Side, often in neighborhoods where much of the violence takes place. During one such workshop, an unenthusiastic young black male, slouching in his chair, said, "That's life, joe. Derrion ain't the only nigga to get murdered in the hood."[4] He was referring to Derrion Albert, a sixteen-year-old Chicago resident, whose fatal beating on September 24, 2009, was seen around the world thanks to a cell-phone video. An honor student at Christian Fenger Academy High School, Albert was murdered by a group of teenagers "in an empty lot next to the Agape Community Center on Chicago's South Side." Ironically, Agape is "one of many [South Side] places where adults are frantically trying to rescue children from drugs, violence, single parenthood and other snares of street life" (Louis 2009, 1). The mob murder took place in the Roseland neighborhood, an area known to many Chicagoans as "The Wild, Wild" or "The Wild Hundreds." The chilling video shows a group of young boys chaotically fighting, onlookers screaming, and many running to and from the danger. After being hit in the head with what appears to be a large piece of wood, Albert drops lifelessly to the ground while mob members continue to punch, kick, and hit him with pieces of lumber. One young man even shouts, "Put that nigga to sleep!" Indeed, they did just that. Toward the end of the video, the mob runs away, but as they go, a few members gather up more wood, suggesting what we already know: that this is no isolated incident.

Both the student's comment and his body language illustrated his commitment to an entrenched patriarchal culture of silence. That is, while acknowledging Chicago's youth violence, they conveyed despair and an assumption that talking is little more than lip service. His reactions also suggested that the violence plaguing the South Side and other areas is so natural that Albert's singled-out murder did not deserve the attention it had received. He continued,

"The violence ain't new. I mean, [Albert] ain't have to go out like that, but ain't nothing gonna change. The media and politicians acting like they care—if they cared they would've tried to stop it a long time ago."

In a 2009 interview, Shadell Jamison, a West Side resident and the host of YCA's weekly open mic Wordplay, told me, "I teach at a [South Side] alternative school on 82nd called Sullivan House, and it's funny how lighthearted [the students] are about [the violence]. They are like, 'It's messed up, but you know what, that's life, it happens every day.'" Because of ambivalence, because of political and journalistic posturing, because of the silence surrounding male violence and the history of youth violence in the city, because of a combination of all of these factors, we have not only lost count of the deaths on the South Side but we have also lost touch.

Despite those obstacles, many young black and brown kids from impoverished areas use slam and spoken word poetry to challenge, escape, or deal with the violence that has become a reality in their everyday lives. If bell hooks (2004a) is correct—that boys, and especially those of color, are asked to sever their emotional parts to become full-fledged men—then performance poetry can be an emotional avenue for these boys, one they can follow to mature into more complex adults who are equipped with better ways to handle their emotions. And while plans to solve the violence are necessary, performances such as Nate and Demetrius's, "Lost Count: A Love Story," which "[aim] to create and contribute to a discursive space where unjust systems and processes are identified and interrogated," have already contributed to local and national dialogues that work toward material change. In their heartbreaking poem, in which the two young men discuss Chicago's gun violence while, throughout the piece, an offstage voice reads off the names of those murdered, they remind us that "one performance may or may not change someone's world," but it can "amass, rather like snowflakes on a steep mountainside, and can set off an avalanche" (Madison 2005a, 538).

"Lost Count: A Love Story" was not created because of YCA, yet that artistic home has given Nate, Demetrius, and many others

like them the space, encouragement, and resources to create art that challenges the city's leaders, its youth, and themselves. More than an artistic safe space, YCA is home—a program in which talented young wordsmiths from all kinds of ethnic backgrounds come together in a way that can only be described as familial. In 2001, in collaboration with Chicago's Writing Teachers Collective, YCA developed Louder Than a Bomb, a citywide youth slam and spoken word poetry festival that embodies Pablo Freire's (2000) notion of dialogue. In this way, the organization is able to spider out to all parts of the city, where it continues to stress the power of performance and poetry to, through, and with young artists from all walks of life. Louder Than a Bomb seeks to make poetry and writing critically relevant to Chicago's youth. It also works with teachers and graduating student-writers, giving them the tools to become poetry teachers in schools on the South Side, the North Side, the West Side, and the surrounding suburbs (Coval 2010).[5] This poetic "public pedagogy" trains young writers to teach and advocate for social justice, and it has brought together an array of "disparate voices in a radically segregated city," performatively showing Chicago's adult poets how to desegregate their poetry venues, to move beyond the city's imagined but real racial divide (Coval 2010, 396). Simply put, it shows them how to cross the street.

On February 20, 2010, I volunteered for Louder Than a Bomb's event Crossing the Street, a creative collaboration among the festival's competing poets. On that cold morning, I watched more than five hundred students, all buzzing with excitement, cram into a South Side school auditorium to work with fellow youth artists from all parts of the city. Crossing the Street functions as an opening ceremony for the larger festival. It mixes up the competing teams, forcing poetic collaboration and meaningful dialogue among South Siders, West Siders, and North Siders; between rival gang members and poets who most likely would never have met. After the event, the students flood out of the auditorium, talking together, forming multiracial ciphers, crossing those symbolic and metaphorical streets.

On the day I attended, students were asked to write a group poem with poets they would later compete against, using Willie Perdomo's "Word to Everything I Love" as a prompt. They wrote about many things they loved, but a constant refrain was their love for Louder Than a Bomb and Crossing the Street. A festival alum, Lamar "Tha Truth" Jordan, told me during a 2007 interview that "Without Louder Than a Bomb, people like me and Adam Gotlieb would have never met." Lamar is a young black man from the South Side; Adam is a young white man from the North Side. He echoed Lamar's sentiment and added during our 2007 interview, "This is truly a gift." The poet and playwright Kristiana Colon, who began working with YCA and Louder Than a Bomb in 2001, told me in a 2007 interview, "Crossing the Street is a microcosm of Louder Than a Bomb, . . . which is a symbol of the cultural idea of valuing the voices, all of them, of our future." But they are more than our future. These young artists and writers are our present. Their voices are urgent, their brilliant creations are gifts, and their work together demonstrated the kinds of collaborations that Chicago's adult poets have yet to comprehend.

There needs to be more research on the youth slam and spoken word scene in Chicago, the Bay Area, New York City, Philadelphia, Los Angeles, and the national scene more generally. We might begin by exploring major organizations and festivals such as the Bay Area's Youth Speaks, Young Chicago Authors, Say Word L.A., Brave New Voices, and the College Union Poetry Slam. These youth programs and festivals will offer rich insights into the future of slam and spoken word as well as the other institutions created by slam and spoken word poets. Additionally, we need to focus on women in slam, not only the problems with male domination but also the lessons we can learn from events such as the Women of the World National Poetry Slam. Likewise, we need to study the place of queer and trans poets in slam and spoken word communities. Such discussions would not only benefit our communities but would also complicate our understandings of the politics of safe space.

Since I began this long ethnographic journey more than ten years ago, much in slam and spoken word has changed. Perhaps we could benefit from a historical account of how slam and spoken word communities arose during the 1980s culture wars and were popularized after 9/11. What is it about these highly political moments that gave rise to such openly political art forms? What was it about Chicago, in particular, that called for such poetics?

At the end of a night of slam, Marc Smith usually says, "We will be here next week, folks. That is the slam, everybody. Thank you for coming out." Thinking of those words reminds me of my time in Chicago, as I headed to the Green Mill on the Red Line on one of those impossibly cold days when the city government was advising people to stay home. Perhaps it is fitting to end this book where the slam began. Perhaps someone else will pick up where I have left off, showing us other ways in which slam and spoken word poets are "killing it." In the spirit of slam, here's to hoping their projects score higher than mine.

Acknowledgments

This book has been a long time coming, and it was only possible because of the extraordinary support of my colleagues, friends, and family. Along the way, some of those colleagues have become dear friends, and some of those friends have become family. To them, I offer all of my gratitude.

Because I am a poet and a storyteller, I will try to start from the beginning so that I do not leave anyone out, though it is almost inevitable that I will overlook a few important people. I offer my thanks and my apologies to them, and I ask for their understanding.

When I was a graduate student at California State University, Los Angeles, Brian Keith Alexander, my master's adviser, urged me to think and write about slam and spoken word poetry. I remember entering his office for our initial thesis meeting and, like most graduate students, was overly ambitious. I told him, "I want to redefine race in my project." He smiled and, like any good adviser, asked if I had considered doing an ethnographic project centering on poetry. Gracefully and generously, he guided me toward an intellectual path that changed my life. During that same 2004–5 academic year, Judith Hamera, who acted less like a reader of my thesis and more like a second adviser, refused to allow me to take any shortcuts and taught me about diligence and intellectual rigor. She nudged me, a boy from South Central, Los Angeles, who had never considered Northwestern University possible, toward her alma mater. I owe both of them, as well as my colleagues Josh Fleming, Stephanie Hood-Fleming, Richie Neil

Hao, Mike Kalustian, Ken Lee, Heidi Mueller-Ochoa, and Rachel Nicole Hasting, so much.

At Northwestern, I was surrounded by a wonderful group of colleagues who supported and challenged my work, among them Chloe Johnston, Mario LaMothe, and James Moreno. I could not have asked for a better cohort. I thank Lori Barcliff-Baptista, Habib Iddrissu, Pavithra Prasad, Jennifer Tyburczy, and Chris Van Houten for ushering me into an excellent program, and I am grateful to my created cohort of black scholars, Racquel Gates, Chike Jeffers, and Rashida Shaw for holding a brotha down. I especially want to thank Jeffrey Q. McCune and Marlon M. Bailey, my big brothers in academia. Your scholarship and continued love are everything.

I thank my professors, Margaret Thompson Drewal, Dwight A. McBride, and Sandra L. Richards, and especially my doctoral committee members, D. Soyini Madison and Harvey Young. E. Patrick Johnson was my adviser, professor, and friend, and his generous guidance and critical care made all the difference. He is a model intellectual and the kind of person I aspire to be. From his advice to "be still and know" to sharing meals at his table, from his classes to his dissertation guidance, from then until now, I could not have accomplished this without him. Thank you, Patrick, so much.

I met some fantastic people during my postdoctoral appointment at the University of Southern California. Thanks to Visions and Voices: The Arts and Humanities Initiative and especially to Daria Yudacufski. Thanks to the Department of American Studies and Ethnicity for giving me a home and to Taj Robeson Frazier, J. Jack Halberstam, Lanita Jacobs, Mark Padoongpatt, and Michael Preston. Special thanks to Tara McPherson and George Sanchez for their mentorship. While I was at USC, I spent time at the California African American Museum as the head of the history department and time doing research at the Schomburg Center for Research in Black Culture in New York City. I thank those much-needed spaces as well.

Thanks to my kind and speedy editor at Rutgers University Press, Leslie Mitchner whom I met while teaching in my current

position at San Francisco State University. I also want to thank Dawn Potter and the entire Rutgers University Press staff. I am also grateful to my manuscript readers, especially Omi Osun, for helping me to sharpen this book. I thank my colleagues in the Department of Communication Studies, notably Rudy Busby, Amy Kilgard, Sam McCormick, Christina Sabee, and Gust Yep, for supporting this project in various ways. And I thank Daniel Bernardi for not only introducing me to Leslie but also providing some financial support when he was interim dean of the College of Liberal and Creative Arts.

Although I do not have the space to name every one of my fellow poets, I thank them all and want to mention a special few here. Thanks to those who agreed to interviews and discussions, especially those who acted as community readers. Thanks also to Dylan Garity, Boris "Bluz" Rogers, and Donny Jackson, and to Imani Cezanne, a brilliant poet who was also my tireless student assistant. I thank Rudy Francisco and Terisa Siagatonu who listened to my rants (also known as work) and provided helpful feedback. I thank Da Poetry Lounge and its family members for knowingly and unknowingly pushing me to make this book possible. I especially want to thank Ron "Shihan" Van Clief for being a mentor in the field. I was doubly lucky to have both an academic advisor and a poetry advisor, but I was even more fortunate to gain you as a friend and a brother.

Finally, to my family whom I love so much, thank you. Thanks to my late stepfather, Foster T. Mijares III, and to my siblings, Tony Johnson II, Foster T. Mijares IV, Dominique Sims, Tramell Johnson, and Martinique Gabourel. Thanks to Rachel Aladdin for being my lighthouse throughout much of this. Thanks to my aunts and uncles, especially my uncle Ronnie and my aunt Renee, as well my grandparents. They all provided the necessary love and laughter that helped me through. Finally, I want to thank my mother, the woman who urged me to continue on after I nearly dropped out of Northwestern because I could not deal with the Chicago winters, the woman who brilliantly raised black children in 1980s South Central, Los Angeles, the woman who would not accept anything

but our best, the woman who sacrificed so much, the woman who demanded that the world open itself to her children in ways it had not for her. I do not write about you often, mainly because I do not think I am good enough. However, that I write at all is a testament to you. I am because you are.

Notes

Chapter 1. Let the Slam Begin

1. *Slam papi* is the name Smith has given himself, and some people call him that.

2. While the pre-slam "rites of passage" process is not a hard-and-fast rule, one might easily understand the separation as the moment when Marc distinguishes his slam from traditional poetry readings ("what makes the slam different ?"), the liminal period as the moment when Marc provides instruction about how to respond to poets and their work, and the reintegration period as the moment when the audience members are done learning their scripts and receive heightened status as slammers (Turner 1982, 94–95).

3. According to Ty Donaldson, the stage is twenty-three feet deep, while the audience area and the booth are about forty feet deep combined.

4. Huggins (1971) contends that the term *renaissance* is often a "historical fiction," although those of this era truly believed "that they were evoking their people's 'Duck of Dawn,'" (3). Mitchell (2010) suggests that the term was not widely adopted till much later. Gallego (2003) argues that the movement overlooked "the important intellectual that preceded and anticipated it" (153).

5. Harrison's (1927) editorial in the *Pittsburgh Courier*, claims "there isn't any" renaissance, that it is a white invention that overlooks "the stream of literary and artistic products which had flowed uninterruptedly from Negro writers from 1850 to the present" (A1).

6. See the chapter "Manifest Faggotry" in Johnson (2003) and Stefanie K. Dunning's (2009) *Queer in Black and White.*

7. Smethurst (2005) offers a complicated and nuanced reading of the Black Arts Movement that recognizes the sexism but also the strong contributions of women.

8. Harper (1996) cites both Alain Locke and Larry Neal as evidence of his claim.

9. President Reagan's destructive economic policies were a backdrop to the rise of hip-hop. Although they did not come into full effect until the early 1980s, they were based on a Keynesian system that was already in place in the late 1970s.

10. Rose (2008) argues against simplistic conservative and progressive readings of hip-hop that suggest it is either all misogynistic and violent or merely a reflection of the truth.

11. Here I differ from Holland (2000), who follows Taussig (1986).

12. Batiste (2011) looks at a wide range of black performance during the Depression, examining black folks' "use of representational structures" that were sustaining U.S. imperialism and how they changed those structures (4).

13. In chapter 3, I discuss the sexual assault allegations at the 2013 National Poetry Slam meeting in more detail.

14. Foucault (1997), extending Nietzsche's "genealogy of morals," makes a theoretical move from "archeology" to "genealogy." I am using genealogy as an analytical tool to expose the historical formations of the "'microphysics' of the punitive power" and "technolog[ies] of power over the human body" (29).

Chapter 2. "This DPL, Come On!"

A version of this chapter appeared as "Manning Up: Race, Gender, and Sexuality in Los Angeles' Slam and Spoken Word Poetry Communities," *Text and Performance Quarterly* 30, no. 4 (2010): 396–419. A special thanks to the editors for allowing me to reproduce it here.

1. A few monthly venues such as the Hawaii Slam and the Flypoet Showcase draw larger numbers, but the Lounge captures large crowds every Tuesday. Perhaps if the Nuyorican Poets Café in New York City, which attracts 150 to 200 audience members weekly, had a bigger space, it would contest DPL's "largest venue" claim. The Nuyo is certainly more

widely known. Both DPL and the Nuyo may be seen as anomalies, however, because most weekly venues are lucky to attract fifty people.

2. Throughout his text, Neal uses *New Black Man* (in italics) to refer to his title as well as the construct, which are one in the same. "Strong Black Man," however, is always seen in quotation marks. In order to maintain consistency, I followed Neal's pattern.

3. DPL will celebrate its twentieth anniversary in June 2018, but that does not include the years spent in Dante's apartment or the two years during which the event moved from venue to venue.

4. *Dope* is a constantly shifting slang term that in this case means "really good."

5. Most DPL business is handled in the kitchen of Greenway Court Theater, making the inherent sexism seem so natural that it goes unquestioned.

6. Gayle (2000) argues that the Black Arts Movement was "a means of helping black people out of the polluted mainstream of Americanism" (xxiii).

7. According to Gerald (1969), whoever has control over the production of images owns the power. Consequently, during the Black Arts Movement, the role of the black writer was to remake the black image, thus gaining control and power.

8. In 2008, I saw Sadiki perform a number of poems, including "Another Day," at word pLAy live, a now defunct Leimert Park poetry venue.

9. Because DPL is a slam powerhouse, many Leimert Park poets associate the venue with slam, which they believe harms the sacred nature of poetry.

10. Stepin Fetchit was a minstrel character played in films by the black actor and dancer Lincoln Theodore Monroe Andrew Perry (1902–1985). Langston Hughes, the NAACP, and other black people and organizations criticized him strongly for depicting blacks as lazy and shiftless. While some of Perry's professional choices are currently seen as subversive and trailblazing, the Stepin Fetchit character still signifies the entertainment industry's long and troubled history of problematically depicting black people (Watkins 2006).

11. Shihan has been more open to dialogue with the Leimert Park poets than I have been. He has also had meetings with many poets who take issue with him or his work.

12. I do not use *queer* for the purpose of calling anyone "out." I am simply highlighting the frequency with which heterosexual men associate their manhood with the conquering of women.

13. Most accounts gloss over the problems in slam and spoken word communities in order to promote ideals of radical democracy. As a result, not much work critically examines these poetry sites. I am currently looking at the ways in which space gets raced in Chicago's segregated slam and spoken word communities as well as how the New York City scene's unhealthy preoccupation with the real and the authentic leads its poets to perpetuate unjust class biases. This chapter is simply an attempt to start the dialogue.

Chapter 3. SlamMasters

1. I use the word *alleged* here because no convictions have taken place. I have not heard all stories first hand because some of the people concerned didn't want to share information for privacy, legal, or safety reasons. At the request of one of the self-defined "survivors," I did not use the names of the alleged victims.

2. Christopher told me that the young woman later recanted her story.

3. Nicole Homer disagrees with my interpretation of her in this text. My five requests for an interview or a statement were denied. Although she did, at one point, agree to take part in a digital interview, she changed her mind, asserting that she does not provide "unpaid labor."

4. The notion that the nuclear family is as toxic as it sounds is a riff on Tongson's (2011) claim in *Relocations: Queer Suburban Imaginaries*.

Chapter 4. Button Up

1. Since 2013, Button has been curated by a group that includes multiple races, genders, sexualities, and ages. However, the general slam and spoken word community believes the platform is strictly managed and produced by Sam and Dylan.

2. The Mahmudiyah rape and killings refer to the U.S. soldiers who gang-raped and murdered fourteen-year-old Abeer Qassim Hamza al-Jabani and murdered her mother, father, and six-year-old sister. Repealed in 2010, "don't ask, don't tell" was a military policy ushered in under the Clinton administration that prohibited discrimination against closeted gay and lesbian personnel while officially barring openly homosexual service members. Josef Fritzl held his daughter, Elisabeth Fritzl, captive for nearly three decades in Amstetten, Austria. He physically and sexually abused her during captivity, and the rape resulted in the birth of seven children.

3. Dylan told me that they had "noticed lately pirated videos doing really well in Twitter's direct video player, particularly a couple [of] videos involving women of color," which pushed them to experiment with videos on Twitter a way to diversify their channel and their audience.

4. PSi chooses among recording bids for each major competition, which at other times have been recorded by SlamFind.

5. World Star Hip Hop has pirated Button's videos, particular those that feature poets of color, which popularizes the poet but does not allow Button or the poets to profit from viewership. Button sent World Star, in Dylan's words, "about ten cease-and-desist letters." I wonder if there is a way to repair that relationship in the interest of diversifying Button and ensuring the success of poets of color, given World Star's massive audience.

Chapter 5. Conclusion

1. The film follows the trajectory of two young black boys around the city after they decide to ditch school.

2. "Good Life" appears on West's 2007 album *Graduation*.

3. Ritual Rhythms has struggled to stay afloat, and at times it has been on hiatus.

4. *Joe* is Chicago youth slang, roughly equivalent to "dude" or "guy."

5. The Writing Teacher Collective was founded in 1999 by Kevin Coval and Anna West, who were inspired by YCA. Members are teacher-writers who use poetry in their curriculum to transform classroom dynamics and empower students.

References

Abu-Lughod, Janet. 2000. *New York, Chicago, Los Angeles: America's Global Cities.* Minneapolis: University of Minnesota Press.

Alexander, Michelle. 2012. *The New Jim Crow: Mass Incarceration in the Age of Colorblindness.* New York: New Press.

Anderson, Benedict. 2006. *Imagined Communities: Reflections on the Origin and Spread of Nationalism. Revised ed.* New York: Verso.

Asante, Molefi K. 1980. *Afrocentricity: The Theory of Social Change.* Buffalo, N.Y.: Amulefi.

———. *Afrocentric Manifesto.* 2007. Cambridge, U.K.: Polity.

Bailey, Marlon. 2013. *Butch Queens Up in Pumps: Gender, Performance, and Ballroom Culture in Detroit.* Ann Arbor: University of Michigan Press.

Banka, Lauren. 2014. Facebook post, November 12. http://www.facebook.com/ lauren.banka?fref=ts. Post has now been deleted.

Barber, David, Harold Bloom, Stephen Burt, Frank Kermode, Richard Lamb, William Logan, Daniel Mendelsohn, Richard Poirier, and Helen Vendler.2000. "The Man in the Back Row Has a Question: VI." *Paris Review* 42 (Spring): 370–402.

Batiste, Stephanie Leigh. 2011. *Darkening Mirrors: Imperial Representation in Depression-Era African American Performance.* Durham, N.C.: Duke University Press.

Belle, Felice. 2003. "The Poem Performed." *Oral Tradition* 18, no. 1: 14–15.

Blackmon, Douglass A. 2008. *Slavery by Another Name: The Re-Enslavement of Black Americans from the Civil War to World War II.* New York: Random House.

Brock, André. 2012. "From the Blackhand Side: Twitter as a Cultural Conversation." *Journal of Broadcasting and Electronic Media* 56, no. 4: 529–49.

Bryant, Leo. 2014. "Superpowers." Uploaded by Button Poetry. Accessed March 19, 2016. https://www.youtube.com/watch?v=ackoHPiAZAs.

Butler, Judith. 1990. *Gender Trouble*. New York: Routledge.

Button Poetry. n.d. Website. Accessed February 15, 2016. http://buttonpoetry.com.

Cam'ron. 2007. "Camron Speaks about 'NO HOMO' [on Hot 97 FM]." Uploaded by JR Rod. Accessed 15 February 2016. http://www.youtube.com/watch?v=WUxMuk-Togk.

Certeau, Michel de, and Steven Rendall. 1984. *The Practice of Everyday Life*. Berkeley: University of California Press.

Cezanne, Imani. 2015. "Flowers." Uploaded by Button Poetry. Accessed November 14, 2016. https://www.youtube.com/watch?v=ctl9ZY3VSus.

Cohen, Cathy. 1999. *The Boundaries of Blackness: AIDS and the Breakdown of Black Politics*. Chicago: University of Chicago Press.

Conquergood, Dwight, and E. Patrick Johnson. 2013. *Cultural Struggles: Performance, Ethnography, Praxis*. Ann Arbor: University of Michigan Press.

Conscious, Tony B. 2007a. "If Langston Hughes Were Alive, Would He Slam?" Blog post, February 5. http://blogs.myspace.com/index.cfm?fuseaction=blog.view&friendId=31844048&blogId=226315828. MySpace posts have now been deleted.

———. 2007b. "Pan African, or 'Slam African'? This Is the Question . . ." *Blog post*, February 5. http://blogs.myspace.com/index.cfm? fuseaction=blog.view&friendId=31844048&blogId=226315828. MySpace posts have now been deleted.

Correa, Teresa. 2010. "The Participation Divide among 'Online Experts': Experience, Skills and Psychological Factors as Predictors of College Students' Web Content Creation." *Journal of Computer-Mediated Communication* 16, no. 1: 71–92.

Coval, Kevin. 2010. "Louder Than a Bomb: The Chicago Teen Poetry Festival and the Voices That Challenge and Change the Pedagogy of Class(room), Poetics, Place, and Space." *Handbook of Public Pedagogy: Education and Learning Beyond Schooling*, edited by Jennifer Sandlin, Brian D. Schultz, and Jake Burdick, 395–408. New York: Routledge.

Crawley, Ashon. 2015. "What I Mean When I Say Neoliberalism." Blog post, December 4. Accessed October 26, 2016. http://ashoncrawley.com/2015/12/04/neoliberalism/.

Crenshaw, Kimberlé. 1989. "Demarginalizing the Intersection of Race and Sex: A Black Feminist Critique of Antidiscrimination Doctrine, Feminist Theory, and Antiracist Politics." *University of Chicago Legal Forum* 140: 139–67.

Dillard, Scott. 2002. "The Art of Performing Poetry: Festivals, Slams, and Americans' Favorite Poem Project Events." *Text and Performance Quarterly* 22, no. 3: 217–27.

Dolan, Jill. 2005. *Utopia in Performance: Finding Hope in the Theatre.* Ann Arbor: University of Michigan Press.

Du Bois, W.E.B. 1926. "The Criteria of Negro Art." *Crisis* 30 (October): 290–97.

Dunning, Stefanie K. 2009. *Queer in Black and White: Interraciality, Same Sex Desire, and Contemporary African American Culture.* Bloomington: Indiana University Press.

Dyson, Michael Eric. *Open Mike: Reflections on Philosophy, Race, Sex, Culture, and Religion.* New York: Basic Civitas.

Echlin, Helena. (2003). "Open Nike." *New Statesman* 132, no. 4664: 43.

Ellis, Lindsey, Anne Ruggles Gere, and Jill L. Lamberton. 2003. "Out Loud: The Common Language of Poetry." *English Journal* 93, 1: 44–50.

Epstein, Joel, and Stacia Langenbahn. 1994. *Criminal Justice and Community Response to Rape. Darby, Pa.: Diane Publishing Company.*

Fisher, Maisha T. 2005. "Literocracy: Liberating Language and Creating Possibilities: An Introduction." *English Education* 37, no. 2: 92–95.

Foucault, Michel. 1997. *Discipline and Punish: The Birth of the Prison*, translated by Alan Sheridan. New York: Vintage.

Fraser, Nancy. 1990. "Rethinking the Public Sphere: A Contribution to the Critique of Actually Existing Democracy." *Social Text* 25, no. 26: 56–80.

Freire, Pablo. 2000. *Pedagogy of the Oppressed, 30th Anniversary Edition*, translated by Myra Bergman Ramos. New York: Continuum.

Freud, Sigmund. 1918. *Reflections on War and Death*, translated by A. A. Brill and Alfred B. Kuttner. New York: Moffat, Yard.

Friedersdorf, Conor. 2015. "Campus Activists Weaponize 'Safe Space.'" *Atlantic Monthly*, November 10. Accessed August 5, 2016. http://www.theatlantic.com/politics/archive/2015/11/how-campus-activists-are-weaponizing-the-safe-space/415080/.

Gallego, Mar. 2003. "Revisiting the Harlem Renaissance: Double Consciousness, Talented Tenth, and the New Negro." In *Nor Shall Diamond Die: American Studies in Honor of Javier Coy*, edited by Carme Manuel and Paul Derrick, 153–66. València, Spain: Publicacions de la Universitat de València.

Gates, Henry Louis, Jr., and Nellie Y. McKay, eds. 2003. *The Norton Anthology of African American Literature*, 2nd ed. New York: Norton.

Gayle, Addison Jr. 2000. "Cultural Strangulation: Black Literature and the White Aesthetic." In *African American Literary Theory*, edited by Winston Napier, 92–96. New York: New York University Press, 2000.

Gerald, Carolyn F. 1969. "The Black Writer and His Role." *Negro Digest/Black World* 18, no. 3: 42–48.

Gluck, Marissa. 2006. "The 'Black Greenwich Village.'" *Curbed Los Angeles, March 21*. Accessed March 6, 2016. http://la.curbed.com/2006/3/21/10607858/the-black-green.

Green, Larry. 1986. "It Could Be Verse: Performance Poets Liven an Old Art." *Los Angeles Times*, November 25.

Greenway Arts Alliance. n.d.. Website. Accessed March 6, 2016. http://www.greenwayartsalliance.org/.

Guerrero, Dan. 2006. *Gaytino!* Performance at Kirk Douglas Theater, Culver City, Calif., June 11.

Halberstam, J. Jack. 2014. "You Are Triggering Me! The Neo-Liberal Rhetoric of Harm, Danger, and Trauma." *Bully Bloggers*, July 5. Accessed August 5, 2016. https://bullybloggers.wordpress.com/2014/07/05/you-are-triggering-me-the-neo-liberal-rhetoric-of-harm-danger-and-trauma/.

Hanhardt, Christina B. 2013. *Safe Space: Gay Neighborhood History and the Politics of Violence*. Durham, N.C.: Duke University Press.

Hargittai, Eszter. 2002. "Second-Level Digital Divide: Differences in People's Online Skills." *First Monday*, April 1. Accessed October 26, 2016. http://firstmonday.org/ojs/index.php/fm/article/view/942/864.

Harper, Phillip Brian. 1996. *Are We Not Men? Masculine Anxiety and the Problem of African-American Identity*. New York: Oxford University Press.

Harris-Perry, Melissa V. 2001. *Sister Citizen: Shame, Stereotypes, and Black Women in America; for Colored Girls Who've Considered Politics When Being Strong Isn't Enough*. New Haven, Conn.: Yale University Press, 2001.

Harrison, Hubert H. 1927. "'No Negro Literary Renaissance,' Says Well Known Writer." *Pittsburgh Courier*, March 12.

Higginbotham, Evelyn Brooks. 1993. *Righteous Discontent: The Women's Movement in the Black Baptist Church, 1880–1920.* Cambridge, Mass.: Harvard University Press.

Holden, Stephen. 1998. "'Slam Nation': Three Minutes to Show You Can Rhyme with Gusto." *New York Times*, July 17.

Holland, Sharon Patricia. 2000. *Raising the Dead: Readings of Death and (Black) Subjectivity.* Durham, N.C.: Duke University Press.

hooks, bell. 2004a. *We Real Cool: Black Men and Masculinity.* New York: Routledge.

———. 2004b. *The Will to Change: Men, Masculinity, and Love.* New York. Washington Square Press.

Huggins, Nathan Irvin. 1971. *Harlem Renaissance.* New York: Oxford University Press.

Hughes, Langston. 1926. "The Negro Artist and the Racial Mountain." *Nation* (June).

Hull, Gloria T., Patricia Bell Scott, and Barbara Smith. 1993. *But Some of Us Are Brave: All the Women Are White, All the Blacks Are Men: Black Women's Studies.* New York: Feminist Press.

Hutcheon, Linda. 2000. *A Theory of Parody: The Teachings of Twentieth-Century Art Forms.* Urbana: University of Illinois Press.

Ingold, Tim. 2014. "That's Enough about Ethnography!" *HAU: Journal of Ethnographic Theory* 4, no. 1: 383.

Iton, Richard. 2008. *In Search of the Black Fantastic: Politics and Popular Culture in the Post–Civil Rights Era.* Oxford: Oxford University Press.

Jackson, John L. 2001. *Harlemworld: Doing Race and Class in Contemporary Black America.* Chicago: University of Chicago Press.

Jackson, Shannon. 2004. *Professing Performance: Theatre in the Academy from Philology to Performativity.* New York: Cambridge University Press.

Jacobs-Huey, Lanita. 2002. "The Natives Are Gazing and Talking Back: Reviewing the Problems of Positionality, Voice, and Accountability among 'Native' Anthropologists." *American Anthropologist* 104, no. 3: 791–804.

Johnson, E. Patrick. 2003. *Appropriating Blackness: Performance and the Politics of Authenticity.* Durham, N.C.: Duke University Press.

———. 2005. "'Quare' Studies, or Almost Everything I Know about Queer Studies I Learned from My Grandmother." In *Black Queer Studies*, edited by E. Patrick Johnson and Mae G. Henderson, 124–57. Durham, N.C.: Duke University Press.

———. 2008. *Sweet Tea: Black Gay Men of the South*. Chapel Hill: University of North Carolina Press.

Johnson, Javon. 2010. Manning Up: Race, Gender, and Sexuality in Los Angeles' Slam and Spoken Word Poetry Communities. *Text and Performance Quarterly* 30, no. 4: 396–419.

———. 2015. "Black Joy in the Time of Ferguson." *QED* 2, no. 2: 177–83.

Jones, Marshall. 2011. "Touchscreen." Uploaded by Speakeasynyc. Accessed November 14, 2016. https://www.youtube.com/watch?v=GAx845QaOck.

Kelly, Esteban Lance. 2010. "Philly Stands Up: Inside the Politics and Poetics of Transformative Justice and Community Accountability in Sexual Assault Cases." *Social Justice* 37, no. 4: 44–57.

"Leimert Park." n.d. *Los Angeles Times: Local*. Accessed March 24, 2016. http://projects.latimes.com/mapping-la/neighborhoods/neighborhood/leimert-park/.

Leimert Park Village. 2016. Website. Accessed March 24, 2016. http://www.leimertparkvillage.org/about.html.

Lorde, Audre. 2007. *Sister Outsider: Essays and Speeches by Audre Lorde*. New York: Crossing Press.

Louis, Errol. 2009. "President Obama, Talk Is Cheap When It Comes to Curbing Youth Violence." *New York Daily News*, October 10.

Madison, D. Soyini. 2003. "Performance, Personal Narratives, and the Politics of Possibility." In *Turning Points in Qualitative Research: Tying Knots in a Handkerchief*, edited by Yvonna S. Lincoln and Norman K. Denzin, 469–86. Walnut Creek, Calif.: Altamira.

———. 2005a. "Critical Ethnography as Street Performance: Reflections of Home, Race, Murder, and Justice." In *The Sage Handbook of Qualitative Research, 3rd ed.*, edited by Norman K. Denzin and Yvonna S. Lincoln, 537–46. Thousand Oaks, Calif.: Sage.

———. 2005b. *Critical Ethnography: Method, Ethics, and Performance*. Thousand Oaks, Calif.: Sage.

Markham, Annette, and Elizabeth Buchanan. 2002. "Ethical Decision-Making and Internet Research: Recommendations from the AoIR Ethics

Working Committee, Version 2.0." *Association of Internet Researchers.*
Accessed February 15, 2016. http://www.aoir.org/reports/ethics.pdf.

Martin, Courtney E. 2002. "Rhythmic, and Rowdy." *Writer* 5 (May): 21–24.

Matam, Pages. 2013. "Pinata." Uploaded by Button Poetry. Accessed March 19,
2016. https://www.youtube.com/watch?v=zgQRkHcEyq8.

McBride, Dwight A. 2005. *Why I Hate Abercrombie & Fitch: Essays on Race
and Sexuality.* New York: New York University Press.

McCune, Jeffrey Jr. 2014. *Sexual Discretion: Black Masculinity and the Politics
of Passing.* Chicago: University of Chicago Press.

Mercer, Kobena. 1994. *Welcome to the Jungle: New Positions in Black Cultural
Studies.* New York: Routledge.

Miller, Monica L. 2009. *Slaves to Fashion: Black Dandyism and the Styling of
Black Diasporic Identity.* Durham, N.C.: Duke University Press.

Mitchell, Ernest Julius, II. 2010. "'Black Renaissance': A Brief History of the
Concept." *Amerikastudien/American Studies* 55, no. 4: 641–65.

Moges, Fisseha. 2011. "For DPL." Performed live at Da Poetry Lounge, Los
Angeles.

Napier, Winston. 2000. *African American Literary Theory: A Reader.* New
York: New York University Press.

National Poetry Slam. 2013. Website. Accessed February 13, 2016. http://
nps2013.poetryslam.com. This site is no longer available.

Neal, Larry. 1968. "The Black Arts Movement: Drama Review, Summer
1968." *National Humanities Center.* Accessed March 6, 2016. http://
nationalhumanitiescenter.org/pds/maai3/community/text8/blacksmove-
ment.pdf.

———. 2000. "The Black Arts Movement." In *A Turbulent Voyage: Readings
in African American Studies*, 3rd ed., edited by Floyd W. Hayes III, 236–
46. San Diego: Collegiate Press.

Neal, Mark Anthony. 2005. *New Black Man.* New York: Routledge.

———. 2013. *Looking for Leroy: Illegible Black Masculinities.* New York: New
York University Press, 2013.

O., Porsha. 2015. "Rekia Boyd." Uploaded by Button Poetry. Accessed July 29,
2016. https://www.youtube.com/watch?v=MNP7H6TxO7s.

Parmar, Priya, and Bryonn Bain. 2007. "Spoken Word and Hip Hop: The
Power of Urban Art and Culture." *Counterpoints* 306: 131–56.

Penmanship Books. n.d. Website. Accessed March 23, 2016. http://penmanshipbooks.com/about-us/.

Penn, Ben. 2013. "LGBT Minorities Face High Unemployment, Job Discrimination, Low Wages, Study Finds." *Bloomberg BNA*, November 18. Accessed October 27, 2016. http://www.bna.com/lgbt-minorities-face-high-unemployment-job-discrimination-low-wages-study-finds.

Phelan, Peggy. 1993. *Unmarked: The Politics of Performance*. London: Routledge.

Poetry Slam Inc. n.d. Website. Accessed February 13, 2016. http://poetryslam.com/.

Rape, Abuse, and Incest National Network. n.d. "The Criminal Justice System: Statistics." *RAINN*. Accessed February 15, 2016. https://rainn.org/get-information/statistics/reporting-rates.

Redmond, Shana. 2014. *Anthem: Social Movements and the Sound of Solidarity in the African Diaspora*. New York: New York University Press.

Rose, Tricia. 2008. *The Hip Hop Wars: What We Talk about When We Talk about Hip Hop—and Why It Matters*. New York: Basic Civitas.

Schradie, Jen. 2011. "The Digital Production Gap: The Digital Divide and Web 2.0 Collide." *Poetics* 39, no. 2: 145–68.

Schultz, Michael, dir. 1975. *Cooley High*. Los Angeles: American International Pictures. Film.

Sedgwick, Eve Kosofsky. 1994. *Tendencies*. New York: Routledge.

———. 1995. *Between Men: English Literature and Homosocial Desire*. New York: Columbia University Press.

Shihan the Poet. 2005. *Music Is the New Cotton*. Independent release. Compact disc.

Siagatonu, Terisa. 2015. "Meauli." Uploaded by Button Poetry. Accessed November 14, 2016. https://www.youtube.com/watch?v=K3xy4rBS-sg.

Siagatonu, Terisa, and Rudy Francisco. 2013. "Sons." Uploaded by Button Poetry. Accessed March 19, 2016. https://www.youtube.com/watch?v=JNPaoszr11U.

Sides, Josh. 2006. *L.A. City Limits: African American Los Angeles from the Great Depression to the Present*. Berkeley: University of California Press.

"SlamMaster Meeting." 2016. National Poetry Slam. Accessed February 15, 2016. http://nps2013.poetryslam.com/for-psi-members/slammaster-meeting/NPSwebsite. This site is no longer available.

Smethurst, James Edward. 2005. *The Black Arts Movement: Literary National-ism in the 1960s and 1970s*. Chapel Hill: University of North Carolina Press.

Smith, Danez. 2014. "Dear White America." Uploaded by Button Poetry. Accessed February 5, 2016. https://www.youtube.com/watch?v=LSp4v294xog.

———. 2014. *[insert] Boy*. Portland, Ore.: YesYes Books.

———. 2015. *Black Movie*. Minneapolis: Button Poetry.

Smith, Marc, and Joe Kraynak. 2004. *The Complete Idiot's Guide to Slam Poetry*. Indianapolis: Alpha.

Soja, Edward W. 1996. *Thirdspace: Journeys to Los Angeles and Other Real-and-Imagined Places*. Cambridge, Mass.: Blackwell.

Somers-Willett, Susan B. A. 2009. *The Cultural Politics of Slam Poetry: Race, Identity, and the Performance of Popular Verse in America*. Ann Arbor: University of Michigan Press.

Taussig, Michael T. 1986. *Shamanism, Colonialism, and the Wild Man: A Study in Terror and Healing*. Chicago: University of Chicago Press.

Taylor, Diana. 2003. *The Archive and the Repertoire: Performing Cultural Memory in the Americas*. Durham, N.C.: Duke University Press.

Thiong'o, Ngũgĩ Wa. 1986. *Decolonising the Mind: The Politics of Language in African Literature*. London: Heinemann.

Tongson, Karen. 2011. *Relocations: Queer Suburban Imaginaries*. New York: New York University Press.

Turner, Victor Witter. 1982. *The Ritual Process: Structure and Anti-Structure*. Ithaca, N.Y.: Cornell University Press.

Vargas, João Helion Costa. 2006. *Catching Hell in the City of Angels: Life and Meanings of Blackness in South Central Los Angeles*. Minneapolis: University of Minnesota Press.

Voedisch, Lynn. 1986. "Poetry Boosters Slam Snob Image." *Chicago Sun Times*, July 25.

Wakefield, Buddy. 2011. "We Were Emergencies." Uploaded by Aiden Kalous. Accessed December 30, 2015. https://www.youtube.com/watch?v=6ZOPmUIG6ME.

Walker, Clarence E. 2004. *We Can't Go Home Again: An Argument about Afro-centrism*. Oxford: Oxford University Press.

Warren, John T. 2003. *Performing Purity: Whiteness, Pedagogy, and the Recon-stitution of Power*. New York: Lang.

Watkins, Mel. 2006. *Stepin Fetchit: The Life and Times of Lincoln Perry*. New York: Vintage.

Williams, Christopher R., and Bruce A. Arrigo. 2004. *Theory, Justice, and Social Change: Theoretical Integrations and Critical Applications*. New York: Springer Science and Business Media.

Williams, Saul. 1999. *S√he*. New York: Pocket Books.

Witcher, Theodore, dir. 1997. *Love Jones*. Los Angeles: New Line Cinema. Film.

Wolcott, Victoria W. 2001. *Remaking Respectability: African American Women in Interwar Detroit*. Chapel Hill: University of North Carolina Press.

Woods, Scott. 2008. "Poetry Slams: The Ultimate Democracy of Art." *World Literature Today* 82, no. 1: 16–19.

Yep, Gust. 2015. "Toward Thick(er) Intersectionalities: Theorizing, Researching, and Activating the Complexities of Communication and Identities." In *Globalizing Intercultural Communication: A Reader*, edited by Kathryn Sorrells and Sachi Sekimoto, 86–94. Thousand Oaks, Calif.: Sage.

Young Chicago Authors. n.d. *Website*. Accessed February 16, 2016. http:// youngchicagoauthors.org/purpose/mission/.

Zuboff, Soshana. 2008. *In the Age of the Smart Machine*. New York: Basic Books.

Index

black bodies: as illegible, 111; as threat, 75–76, 77, 86, 88

black dandyism, 96

Black Eyed Peas, 57, 106

black feminist fatherhood, 49

black gender performativity, 31–32, 84

black image, 15, 33, 40, 46–48, 133n7

black literary tradition, 14–15, 18

black male poets, 23, 30–31, 44, 49, 75, 82

black masculinity: and antagonisms, 30; and family relationships, 98; gray areas of, 108; history of, 46; in LA slam/spoken word communities, 29–39; Leimert Park, 32; and male posturing, 31, 49; performance of, 27, 31, 32, 46, 60; possibilities of, 50; as racial identity, 47; rigid models of, 47; and sexual assault issue, 98–99; and silence, 37; stereotypes of, 46, 48; Strong Black Man image, 32

black militarism, 16, 33, 46

Black Movie (Smith), 103

Black Nationalism, 16, 39–40, 45–46, 47

blackness: and alternative families, 84; degrees of, 42–43; denial of, 28, 44; perceptions of, 71, 77–78; performances of, 15, 22; silencing of, 110; and white consumption, 105

"Black Poem" (Johnson), 44–45

black poets, 15, 20, 22, 23, 27, 84, 105; and archives, 106; banning of, 69; possibilities, sites of, 28; South Side Chicago, 84; and white consumption, 105. *See also* black male poets; black women poets; *specific poets*

black queer persons, 23, 47, 79, 98, 101, 102, 103

black radicalism, 45–46

black rhetoric, 16, 42, 45, 51, 83, 111

black voices: denial of, 28, 54, 77, 111; silencing of, 18, 74, 75, 80, 106, 110; silent, 37, 54, 121–22

black women: and alternative families, 100; and Black Arts Movement, 16; and digital spaces, 110–13; exclu-

sionary practices and, 27, 47, 49, 77, 111; and fathers, 48–49; fears of, 76; and intersectionality, 76; and politics, 102–3, 111; and publishing, 106–7; and violence, 76–77. *See also* black women poets

black women poets, 23, 59, 82, 98–99, 101, 106. *See also specific poets*

Blaetz, Pierson, 11

Blake, John "Survivor," 86

blog posts, 42, 43, 94

Bloom, Harold, 1–2, 14

Bodney, Edwin, 38, 55–59

Bonair-Agard, Roger, 86, 87–90, 116, 119

Boone, Robert S., 119

Boston, 6, 76, 78, 80, 99

boundaries, 14, 18, 23, 24

Brave New Voices National Poetry Festival, 7, 21, 96, 124

Brock, André, 112

Brown, Derrick, 106

Browne, Mahogany L., 106–7

Bryant, Leo, 85–87

Buchanan, Elizabeth, 95

Bukowski, Charles, 67

Butler, Judith, 53

Button Poetry: Button Poetry Books, 21; curators of, 134n1(Ch.4); digital platform of, 91–96; diversity issues, 91, 103–5, 112, 135n3(Ch.4); influence of, 27; poets' responses to, 99–103; power of, 113–15; responses to, 106–13; and World Star Hip Hop, 135n5(Ch.4)

Cam'ron, 51

capitalism, 19, 20, 65, 75, 132n9

Catching Hell in the City of Angels (Vargas), 76

Certeau, Michelle de, 28

Cezanne, Imani, 116

Chicago, 116–25; Chicago poets, 116, 118–19; Green Mill Cocktail Lounge, 3–4, 5, 6, 32, 61, 119, 125; South Side poetic boxing matches, 84; Young Chicago Authors

Dyson, Michael Eric, 17

emotion: and black male stereotypes, 46, 48; and male violence, 37; and "strong black man" stereotype, 35, 122
empowerment, 30, 48–49
Epstein, Joel, 64
ethics, 4, 25, 28
exclusionary practices, 36, 101

family relationships: black family myths, 100; and black masculinity, 98; daughters, 48–49; defined, 82; DPL as, 32–36; fatherhood, 48, 49; and National Poetry Slam (NPS), 70; in slam community, 81–85; as toxic, 134n4(Ch.3); and viral poetry, 99, 100
"Father's Day" (Van Clief), 34
feminism: black feminist fatherhood, 49; "feminist hiss," 4; feminist poems, 35
field poets (term), 43
5th Street Dick's Café, 39
fluidity: of alternative justice practices, 89; and black masculine performance, 31–32, 50; of gender, 39; of intersectionalities, 60; of knowing, 94
Flypoet Showcase, 132n1
Foucault, Michel, 132n14
Fox, Stacy, 116, 119
Francisco, Rudy, 35, 88, 91, 107–10
Freire, Pablo, 123
Freud, Sigmund, 18
Friedersdorf, Conor, 74
Fritzl, Elisabeth, 97, 135n2(Ch.4)
Frohman, Denice, 93–94

Gallego, 131n4
gang culture, 33, 46, 123
Garity, Dylan, 91–94, 104, 134n1(Ch.4), 135n3(Ch.4), 135n5(Ch.4)
Gates, Henry Louis, Jr., 14
Gay, Ross, 106
Gayle, Addison, Jr., 133n6
gay poets/poetry, 34, 55–57, 65–66, 75, 103

Gaytino! (play) (Guerrero), 31
gender issues: alternative gender, 82; fluidity, 39; gender performance, 8, 30, 31–32, 84; gender politics, 48; gender presentation, 50; gender sexuality, 22; and race intersect, 27, 31, 36; and violence, 89
Gerald, Carolyn F., 133n7
Get Lit, 21
Get Me High Lounge, 5
Gibson, Reggie, 84
Gillette, Ron, 6
God, ix, 7, 30, 34, 97, 110
Gomez, Carlos A., 23, 84
Gotlieb, Adam, 124
Graff, Gerald, 25
Gray, Bridget, 36
Green, Larry, 6
Green Mill Cocktail Lounge, 3–4, 5, 6, 32, 61, 119, 125
Greenway Arts Alliance, 11
Greenway Court Theatre, 10–11, 32
Gronniosaw, James Albert Ukawsaw, 14
Guerrero, Dan, 31

Halberstam, J. Jack, 74, 89–90
Hanhardt, Christina B., 75
Hardwick, Omari, 9, 61
Hargittai, Eszter, 96, 105
Harlem Renaissance, 15–17, 131nn4–5
harmony, 81
Harper, Phillip Brian, 16, 42, 47, 132n8
Harrison, Hubert H., 131n5
Harris-Perry, Melissa V., 111
Hawaii Slam, 132n1
Hawley, Shane, 92
"heeeyyy" device, 51
Henderson, Tim "Toaster," 120
heteropatriarchy, 20, 30
heterosexism, 31, 34, 47
Higginbotham, Evelyn Brooks, 30
Hillborn, Neil, 91, 94, 104
hip-hop, 17–18, 33, 39, 46, 132nn9–10
Hogan, Ebony, 116
Holden, Stephen, 6–7

patriarchy, 16, 19, 39–60, 65; assumptions of, 85; and culture of silence, 121; of DPL, 37–38, 47; and homosocial relationships, 51; Leimert Park, 39–50; and male violence, 37; and rape, 86; rethinking, 31, 32

Patterson, Natalie, 35, 38, 58–59

Penmanship Books, 21, 106

Penn, Ben, 101

Perdomo, Willie, 124

performance: and black masculinity, 27, 31, 32, 46, 60; and blackness, 15, 22; and class, 8; and diversity, 8, 28, 39, 44, 81, 82, 117; and fluidity, 31–32, 50; and gender, 8, 30, 31–32, 84; and race, 8, 22, 30; and sexuality, 8, 30, 89

performativity, black masculine, 27, 31–32, 50, 84

"Performing as a Moral Act" (Conquergood & Johnson), 26

Perry, Lincoln, 133n10

Phoenix, Jade, 59

"Piñata" (Matam), 96–98

Poet Ronnie Girl, 38

"Poetry Boosters Slam Snob Image" (Voedisch), 5–6

Poetry Observed, 92

poetry slam: defined, 2–3, 5–6; history of, 3–4; nationalization of, 6–7; rituals of, 4, 13, 125; spoken word poetry comparison, 2–3

Poetry Slam Inc. See PSi

policing, 75, 92, 101

politics, 33, 81; critical dialogue, 8; of language, 36; passing, 101; personal aspect of, 97; of power, 24; of safe spaces, 124; and slam/spoken word poetry, 125

Porsha O., 76–77, 99

power structures, 21, 24–26, 32, 37, 46, 133n7

pre-slam mantra, 4, 131n2

prison-industrial complex. See incarceration

privilege, 36, 37, 52

progressivism, 21, 32

PSi, SlamMaster meetings, 62–63

PSi (Poetry Slam, Inc.): banned poets, 63, 68, 70–71, 79; distrust of, 69–70, 83; as family, 81; laissez-faire attitude of, 66; National Poetry Slam (NPS), 62–63; recording bids, 135n4(Ch.4); and sexual assault issue, 80–81; and Marc Smith, 84; white governance of, 82; Women of the World Slam, 7

publishing houses, 21, 103, 106

Queen Sheba of Atlanta, 68

queer poets: and alternative families, 84; and black masculinity, 50–52; black women poets, 98–103; collateral damage analogy, 78–81, 88; at DPL, 38–39, 54, 55–60; male poets, 38; queer politics, 53; queer slippage, 50–51; and safe spaces, xi, 124; terminology use, 53, 134n12; and viral poetry, 98–99, 103; white, 105

Quickly, Jerry, 10

race, 22, 89; and gender, 27; and gender intersect, 31, 36; performances of, 8, 22, 30

racism, 35–36, 81, 84; assumptions, 87; and black male poets, 49–50; and Button Poetry, 104; critiques of, 94; racial stereotyping, 17

radicalism, 21, 81, 134n13

Raising the Dead (Holland), 18

Ramirez, Adriana E., 71

rape culture, 88, 89, 96–98. *See also* sexual assault

rap/rappers, 17, 29–30, 51, 83

Red Storm, 119

"Rekia Boyd" (Olayiwola), 76–77

Relocations (Tongson), 134n4(Ch.3)

Rendall, Steven, 28

repertoire, 27, 94–95

Rickets, Emmanuel "Def Sound," 83

Ritual Rhythms, 119, 135n3(Ch.5)

rituals, of poetry slam, 4, 13, 125

About the Author

JAVON JOHNSON is an assistant professor of African American stud-ies at the University of Nevada, Las Vegas. He earned his Ph.D. in performance studies from Northwestern University. Johnson writes for the *Huffington Post*, the *Root*, and *Our Weekly* and serves on the editorial board of *Text and Performance Quarterly*. He is also a prominent spoken word poet.